IMAGES
of America

IDAHO FALLS

William Hut

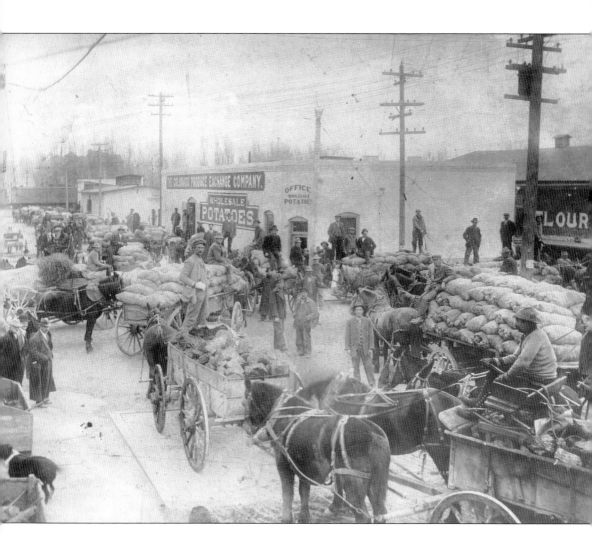

ON THE COVER: From the earliest days of the railroad through the 1940s, farmers brought produce in horse-drawn wagons to the weigh scales on Market Street, or "Spud Alley" as it was called, to be inspected and loaded for shipping. The street was the back side of Idaho Falls' business district and ran parallel to Broadway, still the downtown's main street and first to be paved around 1910. Now Market Street is a parking lot behind Chesbro's Music and the Antique Gallery. (Courtesy Bonneville County Historical Society [BCHS] and Museum of Idaho [MOI].)

IMAGES
of America

IDAHO FALLS

William Hathaway

ARCADIA
PUBLISHING

Published by Arcadia Publishing
Charleston SC, Chicago IL, Portsmouth NH, San Francisco CA

Printed in the United States of America

Library of Congress Catalog Card Number: 2006931270

For all general information contact Arcadia Publishing at:
Telephone 843-853-2070
Fax 843-853-0044
E-mail sales@arcadiapublishing.com
For customer service and orders:
Toll-Free 1-888-313-2665

Visit us on the Internet at www.arcadiapublishing.com

This book is dedicated to the late Jack C. Barry, whose tales of growing up on the cavalry posts of the American West continue to flavor and inspire our family's interest in the region's rich history.

CONTENTS

ACKNOWLEDGMENTS

Special thanks to the Bonneville County Historical Society and Museum of Idaho for providing information and many of the photographs for this book and especially the aid of LaDean Harmston and Judy House in the Museum of Idaho's Reading and Reference Department. This book is indebted to Mary Jane Fritzen, whose 1991 Bonneville County Historical Society publication "Idaho Falls, City of Destiny" preserved a detailed outline of the events that shaped Idaho Falls. William Stibal Pettite has also done much to preserve and authenticate the facts surrounding local events. Edith Haroldsen Lovell's 1963 book *Captain Bonneville's County* is a treasure trove of first-person accounts from the area's pioneers.

For 125 years, the history of the region has been told in the pages of its newspapers. Dapper William Wheeler practiced a lively personal brand of journalism at the *Register* for nearly four decades. At one time, the town of 4,000 had three very competitive newspapers. They all merged in 1931 to form the *Post-Register*, and the Brady family has run it for more than 80 of its 125-year history.

The late Joe Marker was the *Post-Register*'s history editor and author of *Eagle Rock, U.S.A.* He led a legion of ink-stained wretches whose decades of newspaper accounts have resulted in a fairly detailed record. Special thanks to Linda Metcalf, who spent a good deal of time in 2005 extracting tidbits from the newspaper's 125 years of microfilm files for the *Post Register*'s anniversary edition. Thanks also to those writers and photographers who contributed articles to various special editions celebrating the area's history over the years and form much of the background of this book, and to Roger Plothow, J. Robb Brady, and Marty Trillhaase for reading and offering valuable comments and guidance.

INTRODUCTION

This book tells how civilization—schools, libraries, law, and music—came to Idaho Falls. Taylor's Crossing was a narrow gap in the lava rock that funneled the raging Snake River, a natural place for a bridge. The town became Eagle Rock, a rip-roaring stop midway along the Old Montana Trail, and thanks to the railroad, it grew into an expanding hub of commerce called Idaho Falls.

The spot on the Snake River that became Idaho Falls has always been a crossroads. In prehistoric times, buffalo and other game made trails along the western slopes of the Continental Divide, followed by nomadic Native American family groups who hunted along the riverbanks, cached food in the desert's ice caves, and mined obsidian cliffs to the north for arrowheads and tools.

Trappers and adventurers visited the region. Capt. J. Howard Stansbury completed a military reconnaissance of the area in 1849, calling it "the best natural road I ever saw." Today's interstate highways still closely follow the ancient north-south game trails and Native American migration routes. According to Brigham D. Madsen, author of several scholarly books who served for years as the tribe's official historian:

> As an avenue of communication from the Great Plains to the Pacific Northwest, Snake River Valley cut through a whole series of ridges which, running north and south in the basin and range country of the interior West, interrupted travel across the continent. Cultural interchange, fostered by this natural route of travel, continued from prehistoric times down past the years of the fur trade.

One of the area's first permanent white settlers was Richard "Beaver Dick" Leigh, an Englishman who came to the mountains around 1858 at the tail end of the fur-gathering era to live with his Shoshoni wife, Jenny, in the Native American style.

Though not a farmer, Richard Leigh grew vegetables and feed for his horses and other livestock. Of limited education, he kept up a diary and correspondence throughout most of his life and wrote shortly before he died that "i ave the pleshur of knowing that i ave led the setlements on snake river and showed them ware they could keep stock and farme."

Unlike the settlers who moved along the Oregon Trail, those who used the California Trail and its northern leg, the Old Montana Trail, were mostly bent on striking it rich and moving on. Temporary towns took hold for teamsters and railroad men, cowboys, and a few ranchers and family farmers.

From a rough-hewn toll bridge to a railroad headquarters and then a fertile agricultural center and national research lab, Idaho Falls has grown steadily despite wars, economic recessions, and disasters—both natural and man-made.

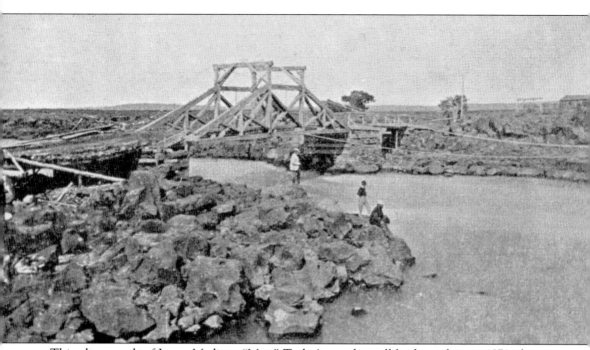

This photograph of James Madison "Matt" Taylor's wooden toll bridge, taken in 1871, shows a rough-hewn structure that was nevertheless the best way to get across the turbulent Snake River during the earliest days of travel along the Old Montana Trail. Previously travelers had to ford the river at wide, shallow spots, or ferry across. This was the second bridge to be built by Taylor across the narrow span of lava at Eagle Rock. The first was washed out in 1866, a year after being built, and the new bridge was built higher and better. Photographer William Henry Jackson took a picture of the bridge in 1872 when the Hayden Survey came through. The river itself had a number of early names; Lewis and Clark dubbed it the Lewis River, but to Hunt's Astorians the South Fork of the Snake was known as the Mad River. British explorers called it the Great South Branch of the Columbia. Early newspaper accounts are filled with tragic stories of accidental drownings during spring runoff when the river was especially treacherous. The outpost that became Eagle Rock and then Idaho Falls was first called Taylor's Crossing, after the bridge and the man who built it. (Courtesy BCHS/MOI.)

One

THE RAILROAD
TRANSFORMS EAGLE ROCK

Eagle Rock's population swelled when the Utah Northern Railroad's construction camp arrived in April 1879. A two-section steel bridge was completed about 100 feet south of the toll bridge owned by the Anderson brothers and shortly after the railroad established its Idaho headquarters at Eagle Rock. Some of the commerce followed the railroad north in the following months, but unlike other temporary construction bases, Eagle Rock didn't disappear.

The renamed Utah & Northern Railway Company began service to Butte, Montana, by 1881. By May 1884, the railroad was the biggest employer in Eagle Rock. Other businesses followed, and new settlers continued to arrive by rail. Facilities in Eagle Rock expanded to include several two-story office buildings, a machine shop, a blacksmith shop, a tin shop, a large boardinghouse, and several small houses.

Then on May 22, 1886, everything changed. At about 2:30 p.m., a strong windstorm blew down the railroad's major maintenance building. The workers inside were saved by the locomotives, which prevented the roof and walls from falling on them.

The railroad, which had faced local labor strikes during that year and the next, decided to rebuild its repair shops in Pocatello. The Union Pacific dismantled all the remaining machine shops—the forge, offices, and company houses—placed them on flat cars, and shipped them south. The transfer was completed by December. With the facilities went about 150 jobs.

The town's population quickly dropped from 1,400 to about 500, but it turned out to be a temporary setback. Soon Eagle Rock was shipping large amounts of produce to markets by rail, and a brewery was supplying nearby towns with beer. As irrigation improved and farming increased, the city remained the most important shipping point on the line from Ogden to Butte.

Starting in 1883 with a call from the leaders of the Church of Jesus Christ of Latter-day Saints, Mormon settlers began to pour into the area, building canals and laying out town sites all up and down the Upper Snake River Valley.

The narrow-gauge line from Pocatello to Silver Bow, Montana, was converted to standard gauge in 1887, so freight would no longer have to be moved from one set of wheels to another. Extensive preparation allowed about 40 crews to complete the work in one day—July 24.

In 1889, the Union Pacific's Oregon Short Line created the St. Anthony Railroad, which took passengers and freight from Idaho Falls to that St. Anthony's, a town about 40 miles northeast of Idaho Falls. From there, they were carried by carriage to Jackson Hole and Yellowstone. The rail line was eventually extended to Victor and West Yellowstone, Montana. Other lines were planned but were never constructed.

The Oregon Short Line advertised the area to potential homeowners in a pamphlet that exaggerated its potential for farming. It also offered special summer excursion fares. A round-trip ticket to Salt Lake City from Idaho Falls cost $9.50 in 1891. Ads hailed Idaho Falls as an "outfitting point" for visitors to Yellowstone Park. The railroad was the main conduit for shipping the area's potatoes, sugar beets, wheat, and barley until trucking overtook it in the 1960s.

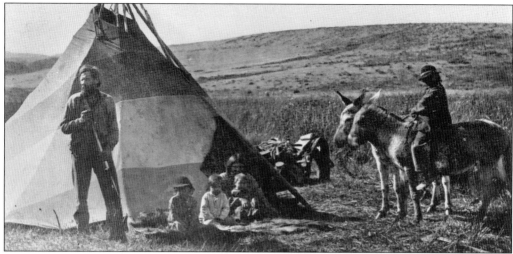

Mountain man Richard "Beaver Dick" Leigh and his first family are seen here at their campsite in this rare photograph from the Bonneville County Historical Society. Leigh was said to have married Jenny, a maiden of Chief Washakie's people, when she was 16 years old. Leigh made certain a minister presided over the ceremony, and it was said he deeply loved the young woman who seemed cut out to share his rugged lifestyle.

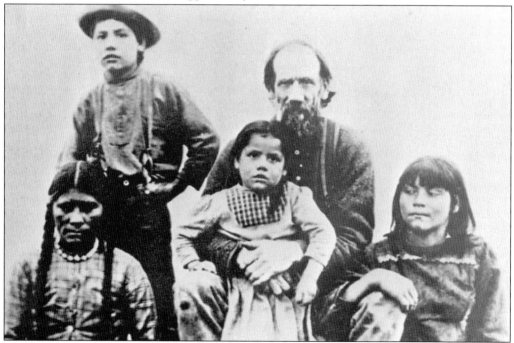

Leigh poses with his Shoshoni wife, Jenny, and their children. Leigh lost his beloved Jenny and family to smallpox in 1876. Fluent in the Bannock and Shoshone languages and knowledgeable in Indian sign language and smoke signals, Leigh was instrumental to Ferdinand V. Hayden, founder of the U.S. Geological Surveys of the territories, and guided many who played a role in American history, including Theodore Roosevelt. The president even described Leigh in his journals. In Grand Teton National Park, Leigh Lake was named for him, and Jenny's Lake was named for his wife. (Courtesy *Post-Register* [PR].)

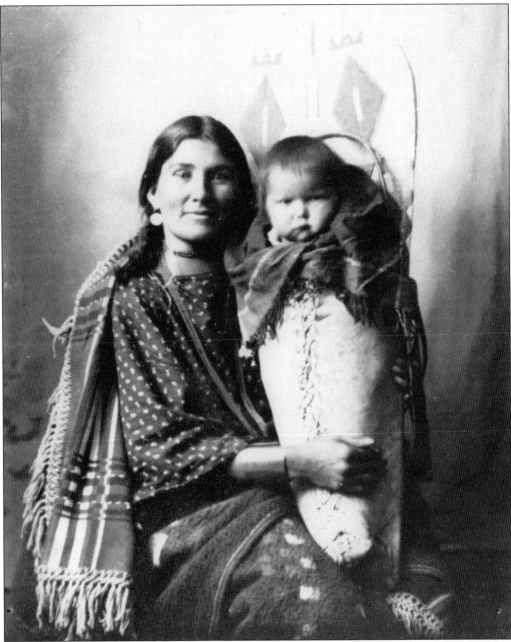

A woman of the Bannock tribe is seen with a baby in a cradleboard, used as part of a method for carrying children among nomadic Plains and Plateau Basin cultures. Native American populations in the region date back more than 8,000 years. The Bannocks of eastern Idaho are a Northern Paiute culture who generally lived in harmony with their Shoshone and Lemhi neighbors. Bannocks numbered about 1,000 in the region upon arrival of the white man and Shoshones about 1,500. The heart of the Bannock country was described as lying just below the forks of the Snake River. (Courtesy BCHS/MOI.)

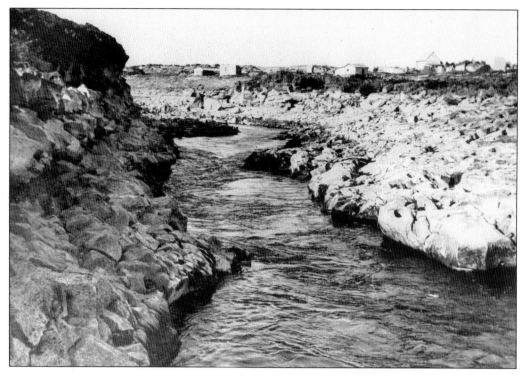

The Snake River narrows to less than 100 feet through a gap at Eagle Rock (above, buildings in the background), making it an ideal location for the first bridge (below), built in 1865. Traffic on the bridge grew as the mines and towns to the north and west sprang up, and Taylor's Crossing, midway between Butte and Salt Lake City, became a convenient stopping place. "For a vital 20 years, the north-south Montana Trail rivaled and probably surpassed the better-known Santa Fe Trail in the number of freight wagons and travelers using it," historians Betty and Brigham Madsen remarked. (Courtesy BCHS/MOI.)

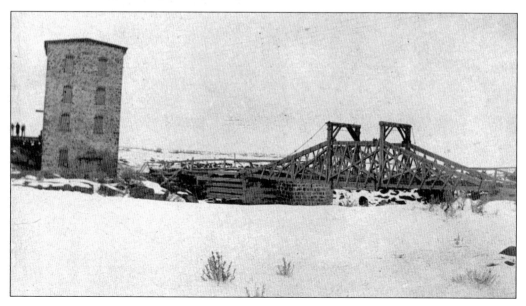

Capt. Benjamin L. E. Bonneville explored the Upper Snake River Valley from 1831 to 1833. Several explorations and trading parties came through the region, including Andrew Henry (1810) and Peter Skene Ogden. Washington Irving chronicled Bonneville's travels and the county is named after him. Eagle Rock was originally part of Oneida County, then Bingham County. (Courtesy PR.)

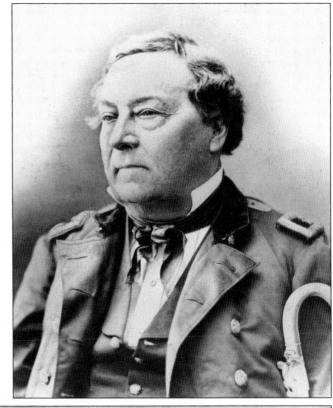

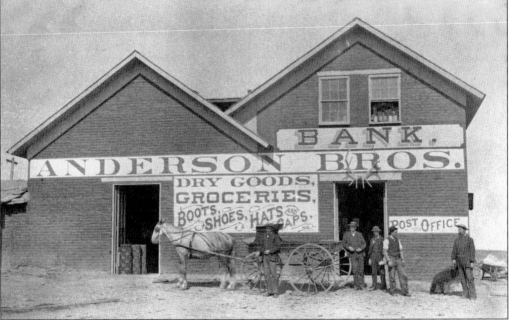

This is the Anderson Brothers trading post and bank at Eagle Rock. The brothers ran the first mercantile in the Snake River Valley, which lasted until 1900, when Robert Anderson sold out to a St. Louis company and took a long vacation to Scotland. (Courtesy BCHS/MOI.)

The Dest family homestead, seen here in the summer of 1908, was one of the first along the Cedar Hollow and Foothills Canal and was purchased by a group of Denver-based developers who pushed through Eagle Rock's name change to Idaho Falls. In a 1991 newspaper account, an early settler recalled that other settlers knew the region was fertile because the sagebrush grew "so high, mothers would lose their children." (Courtesy PR.)

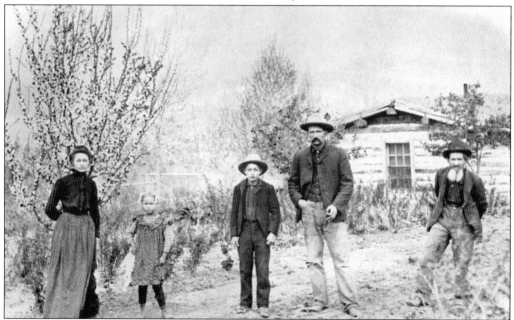

Pictured here, from left to right, early Eagle Rock settlers Elizabeth, Elsie, Clifford, and Henry Jemmett and Dusty Banks pose outside the family homestead. Living along the banks of the turbulent Snake River was hard. Several accounts exist of drownings when settlers tried to cross the river by boat or herd animals across the treacherous stream. (Courtesy PR.)

Tom Edmo, a Bannock tribal judge, is seen in traditional dress holding a coup stick and wearing a buffalo horn cap. In 1878, the fierce Bannock tribe faced starvation at the hands of whites on the nearby Fort Hall Reservation, which they shared with Shoshonis and Lemhis at about the time the Utah Northern Railroad began building on reservation lands. Bannocks, joined by members of various other tribes, chose war in May. More than 200 Native Americans died; nine soldiers and 31 settlers were killed. Most of the surviving Bannocks were eventually returned to the Fort Hall Reservation or came back on their own. (Courtesy BCHS/MOI.)

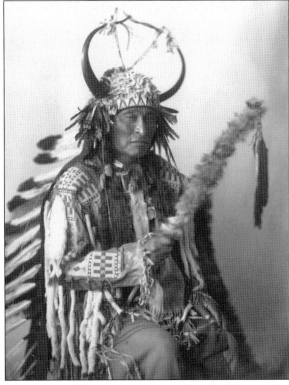

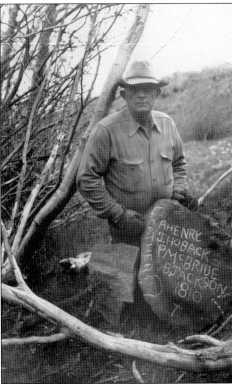

This stone marker was found by Hazen Hawkes, seen here near St. Anthony at the site of Fort Henry. The rock reads, "A. Henry, J. Hoback, P. McBride, B. Jackson 1810." It was a lean winter spent on what later became the Henry's Fork of the Snake River. (Courtesy PR.)

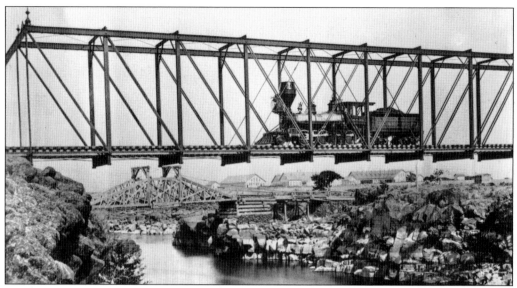

This well-known c. 1887 photograph shows the Utah and Northern Railroad bridge in the foreground and Taylor's Crossing toll bridge in the background, with railroad shops finished in 1881 visible in the distance. The wooden toll bridge lasted until 1889 when it was condemned and replaced with a steel bridge. (Courtesy Utah State Historical Society.)

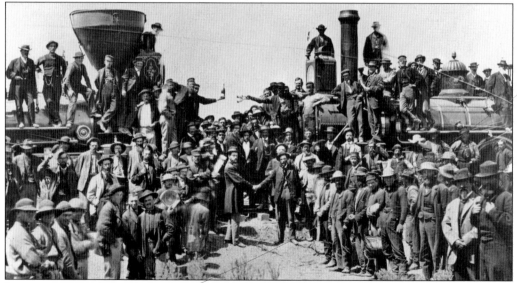

Locomotives similar to the Jupiter engines, operated by the narrow-gauge Utah and Northern Railroad, united the country at Promontory Point, Utah, in 1869. Less than a decade later, the railroad reached Eagle Rock. Its coming was a boon to business but signaled more trouble for Native Americans. The railroad's right-of-way through the Fort Hall Indian Reservation in 1881 was made over the objections of Bannock leaders, who were upset that as many as 200 whites were already residing unlawfully on the reservation. "The cession . . . reminded the more thoughtful Indians that their location at the junction of the old Oregon, California and Montana trails could have certain liabilities," according to historian Brigham Madsen. A large tract of reservation lands was sold off in an Oklahoma-style land rush in 1902. (Courtesy BCHS/MOI; Joe Marker collection.)

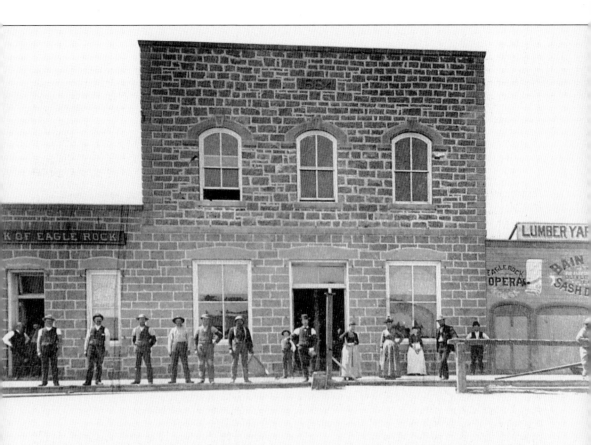

Customers and clerks line up along Eagle Rock Street in front of the bank (left), Eagle Rock Opera (right), and a lumberyard. The main lava-rock building was constructed in 1884. The Anderson brothers donated land to the Utah Northern Railroad for shops. The railroad's arrival triggered a movement of merchants north from Blackfoot and Utah. Very shortly, the town was swamped with speculators. "The rush is so great that sleeping accommodations are out of the question," reported the *Salt Lake Tribune* in May 1879. (Courtesy BCHS/MOI.)

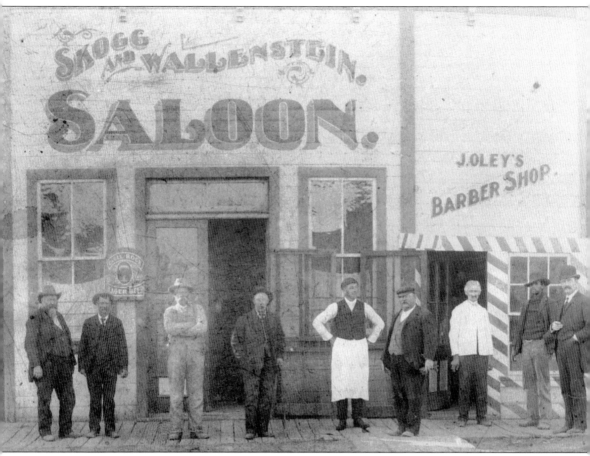

Patrons of Skogg and Wallenstein Saloon pose for a photograph. Note the billboard by the door advertising Eagle Rock Lager Beer. The "purity" of the brand was advertised in the 1904 *Register* as endorsed by the United States Health Bulletin, which was "the American authority on matters of health, sanitation and hygiene." (Courtesy PR.)

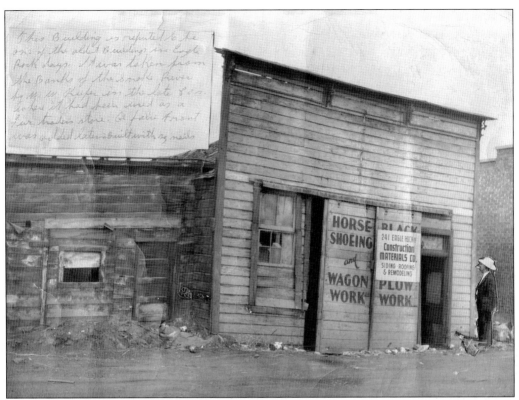

Taken from the banks of the Snake River by W. W. Keefer in the late 1880s, this photograph shows one of the oldest commercial buildings in Eagle Rock, a former fur-trading store at 241 Eagle Rock Block. The figure of a man at right appears to have been inserted later. (Courtesy BCHS/MOI.)

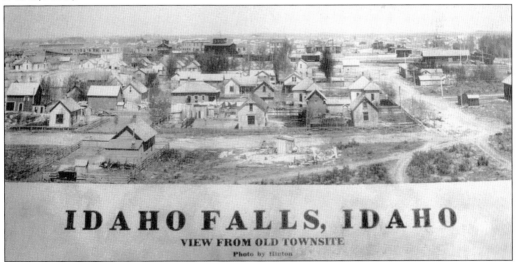

This early view of Idaho Falls looks east from the river in a so-called "panorama" technique popular in the early 1900s. Most houses had corrals or barns for horses and fenced yards for poultry and small livestock. The village employed a herder to keep an eye the town's dairy cows. (Hinton photograph; courtesy PR.)

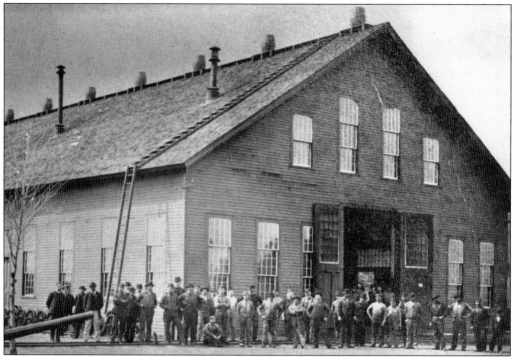

The Eagle Rock railroad roundhouse is seen here with a Utah and Northern locomotive on the tracks. The railroad soon replaced freight wagons and stagecoaches as the primary means of long-distance travel. Engines were less than 30 feet long, and engineers depended on hand brakes and backward motion to slow down or stop the trains. All trains were decorated with brass and had large oil-lamp headlights and balloon-style smokestacks. Passenger coaches and sleeper trains were included on the Utah Northern. Coach cars were capable of seating 46 people. (Courtesy PR.)

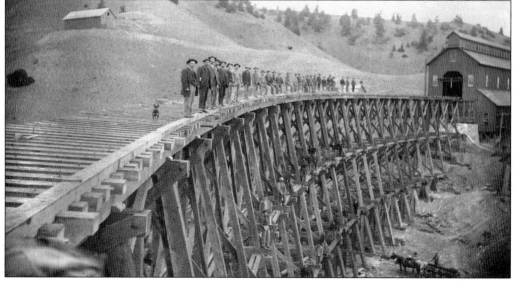

The work gang poses on a railroad trestle built by prominent local contractor W. W. Keefer. Much of the timber for early bridges and trestles came from Beaver Canyon north of Dubois, including the timbers used for the original Taylor toll bridge in 1865. (Courtesy BCHS/MOI.)

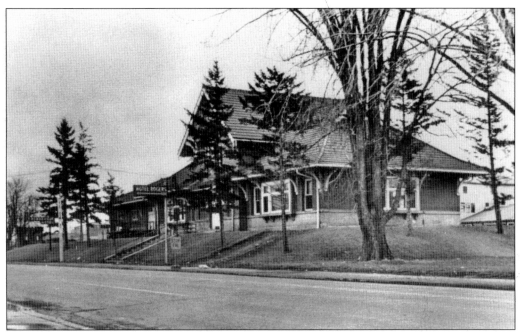

The passenger depot on Cottage Avenue was located near where a rock cistern now stands, just south of the present railroad underpass. Cottage Avenue was lengthened and became North Yellowstone Highway following construction of an underpass beneath the tracks. (Courtesy BCHS/MOI.)

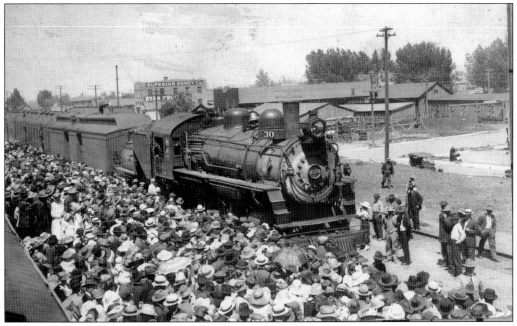

A coal-burning locomotive pulls a passenger train to Idaho Falls as a crowd gathers at the station. One of many railroad depots built in Idaho Falls, the passenger depot was located at the corner of Cottage and C Street (now Constitution Way). (Courtesy BCHS/MOI.)

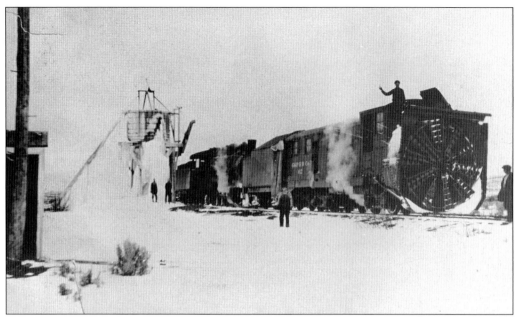

During hard winters, a rotary snowplow was used to keep tracks open to the north. Often the track-clearing trains returned with a load of ice to be stored in Idaho Falls for use during the following summer. (Courtesy BCHS/MOI.)

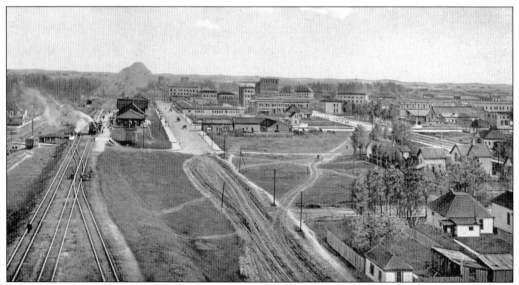

This is a view of the train depot on Cottage Avenue, looking south, with downtown Idaho Falls at right. Traffic through the city had increased so much that the railroad opened a large new depot. The March 2, 1911, *Idaho Register* reported, "The building and opening of this depot . . . is a distinct recognition of the present importance and future greatness of Idaho Falls as a place of business and railway importance." (Courtesy BCHS/MOI.)

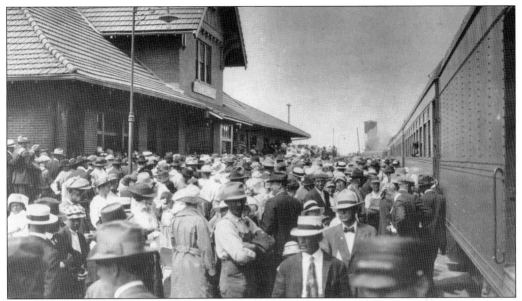

A crowd of businessmen display an array of hat styles as they gather at the train station to greet incoming passengers. The photograph was probably taken during or just after World War I ended in 1918. (Courtesy BCHS/MOI.)

The passenger train depot was demolished during the widening of Yellowstone Avenue in 1965. Passenger service had dropped off since the 1920s as automobiles increased and was discontinued in 1971 when Amtrak took over. (Courtesy BCHS/MOI.)

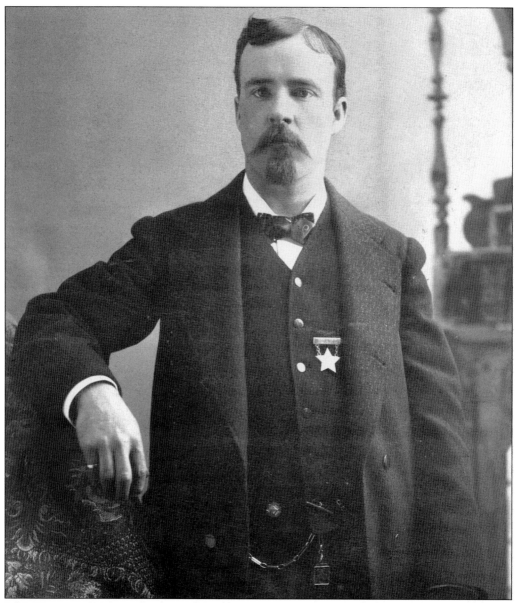

Ed F. Winn was Eagle Rock's first resident lawman, serving as an Oneida County deputy starting in 1880 and then as a deputy U.S. marshal. Winn wore pearl-handled .44-cailber six-shooters mounted in swivel holsters and was involved in several deadly gunfights. His nephew, R. A. Winn, recalled him as a "cocky little bantam." He is reputed to have tracked a fugitive to Island Park in winter, returning with his head in a bag and displaying it on the back bar of his saloon to await the circuit judge. A staunch Republican, he was licensed as a private detective and held dozens of passes to ride free on railroads and steamship lines. He was the town's first fire chief and was appointed postmaster in 1906 but resigned under a cloud of controversy. Winn partnered with Dick Chamberlain in a billiard parlor and saloon, then later was convicted of bootlegging for opening a saloon in a dry county. He died in 1935 of cirrhosis of the liver. His wife preceded him in death and he willed his estate, including rents and funds from the Ed Winn Building on Park Avenue, "to be utilized by the poor and unfortunate of Idaho Falls." (Courtesy BCHS/MOI.)

Two

THE STRUGGLE FOR LAW AND ORDER

More than 100 people were murdered in eastern Idaho and western Montana during the months of Sheriff Henry Plummer's reign in 1863 and early 1864. Plummer, a member of San Francisco's infamous vigilantes, became the secret ringleader of a gang of stagecoach robbers known as "The Innocents." On May 24, 1863, he was elected sheriff for a large area that included Eagle Rock and the Snake River plains.

Vigilantes grew sick of the violence, and on January 10, 1864, they hanged Plummer and several gang members on a scaffold in Bannock City. His commission as Idaho Territory U.S. marshal arrived after the execution. Finding a list of names on Plummer when he was arrested, vigilantes tracked down other members of his gang, some of whom had fled south into eastern Idaho.

Thereafter, through necessity and the early example of the vigilantes, self-appointed enforcers sprang up from time to time among the ranks of saloons and billiard halls where trouble seemed most likely to occur, such as saloon keeper Dick Chamberlain and his partner, Ed F. Winn. According to a history written for the Daughters of the American Revolution by Eldora Keefer, Chamberlain "kept a rough house and many fights and shooting scrapes took place in his building." Winn was the town's first resident lawman and became a deputy U.S. marshal in recognition of his prowess at regulating cattle thieves in the area.

After an 1891 name change, Idaho Falls fought to preserve its wilder side. During the city elections of 1904, saloon keepers complained that they might have to go out of business if they were going to be "regulated" so much. Following the elections, a new ordinance allowed saloons to remain open all night instead of closing at midnight.

Following another wave of reform, by July 1907, the *Register* reported that the city council had taken "drastic measures," ordering enforcement of an ordinance "keeping the saloons closed within hours, closing down the so-called 'red light' district and compelling drug stores not to sell liquor in violation of the statutes lest they fall under the extreme penalty of the law."

The town continued to have trouble enforcing liquor and gambling laws. By the 1920s, the city of Idaho Falls provided a car for the police department instead of having officers use the fire department's car. "Beat lights," similar to traffic lights, were installed around town. When police were needed, someone flipped on the lights, and any officer who saw them flashing went to a pay phone, called the police station, and asked where they should go. Idaho Falls was the largest city in the state to approve slots, with 233 licensed in 1949. The Idaho legislature declared slot machines illegal in 1954, leaving Nevada as the last state where slots were legal.

During the 1950s, police duties included shaking the doors of downtown businesses, turning off lights, and stoking furnaces. Defendants convicted of vagrancy or disorderly conduct were often ordered to "get out of town and not come back." In January 1978, the police department moved into the city-county Law Enforcement Building.

Dick Chamberlain was also known as "Captain Dick," "Uncle Dick," D. F., Dan, or Dave. Chamberlain claimed to have been an officer in the Union Army and founded the local chapter of the Grand Army of the Republic, then commanded the town's first company of National Guard. By 1882, he owned a two-story building with a saloon and billiard hall on the ground floor and an organ upstairs for dances, while next door there was a 10-pin bowling alley. He rented out rooms above his saloon. Chamberlain and Winn also started the town's first fire department, and Chamberlain was appointed to the village council in 1889. (Courtesy Eagle Rock Masonic Lodge No. 19.)

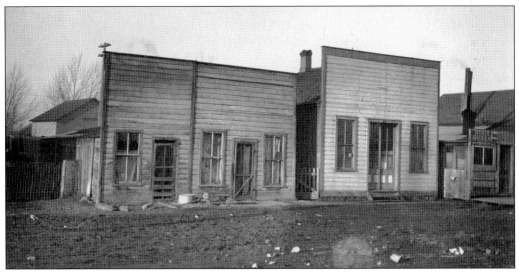

These false-front storefronts line an unpaved street around 1890. In 1885, a fire burned out nearly all the frame shacks along Eagle Rock Street, so citizens met at the Brewery Saloon and organized the first fire department. The first fire station was located at Broadway and Capital Avenues. The station and equipment—a hand cart with 300 feet of hose—were owned by the volunteer organization. (Courtesy BCHS/MOI.)

This photograph in the Museum of Idaho's records room is identified only as an early day sheriff of Eagle Rock. The horse and dog are also unidentified. (Courtesy BCHS/MOI.)

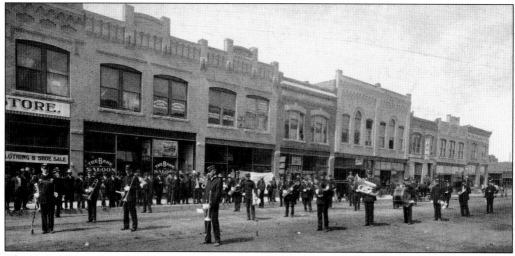

The O. P. Thayer Band led mourners down Broadway Avenue for Dick Chamberlain's burial in 1908. Chamberlain started the town's first cemetery, about two and a half blocks south of the Broadway Bridge, in the 1880s. Chamberlain charged $5 for a lot of six burial plots and ran the growing cemetery from his saloon. "Several troublemakers went straight from the saloon to the cemetery, with Dick moving from selling a shot of whiskey to peddling a plot," reported historian William Stibal Pettite. Research by Mrs. Barzilla Clark later turned up evidence of several hundred graves, but Chamberlain's record keeping was faulty and interments were done in a haphazard manner. Chamberlain tried to sell the 13-acre cemetery to the village board in 1892 for $50 an acre, but many of the plots turned out to be on government land. Chamberlain walked away from the project, and the *Register* began a campaign for a new cemetery. Most of the bodies were relocated, including remains found during road work or construction. When Chamberlain died, the whole town turned out for his funeral. (Courtesy BCHS/MOI.)

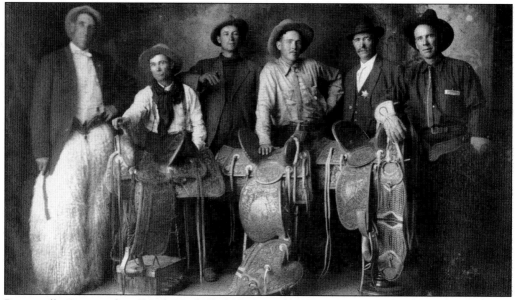

Bonneville County sheriff Jack Hayball, fifth from the left, poses with the first prizes given to winners at the War Bonnet Round-Up in 1912. Hayball also served as one of Idaho Falls' first police chiefs. (Courtesy BCHS/MOI.)

Handcuffs and billy club are inscribed to "Jno. (John) Boyes," who served as the second police chief of Idaho Falls around the turn of the century. As the town grew, law and order took root. In the early 1900s, officers stopped people who rode horses or mules at a "reckless speed." Another law prohibited riding bikes or tricycles on the sidewalk. W. W. Keefer built the first jail for $234, and the cost was shared with the county. (Courtesy Ryan and Linda Rumsey.)

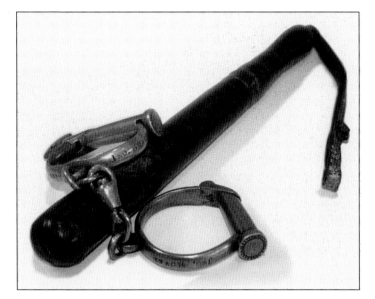

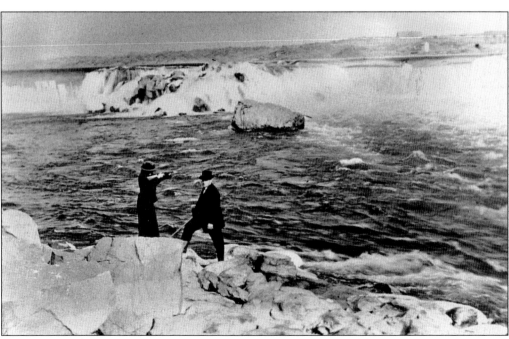

A competence with guns was necessary for self-defense as well as good hunting luck. A photograph taken around 1910 shows a couple in Sunday clothes taking target practice just below the falls downtown. (Courtesy PR.)

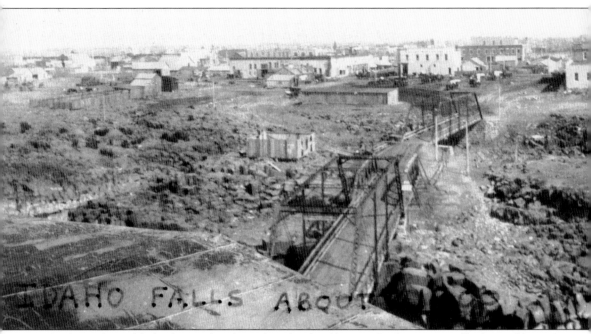

IDAHO FALLS ABOUT

Eagle Rock's red-light district lay along the islands of lava rock where originally the eagle's nest that gave the town its name had been located. Access from town was by the wagon bridge (left) or along the railroad trestle (right). This photograph was taken around 1900, just after the Village Improvement Society formed and a year or two before it bought the land under the red-

Market Street, also called "Spud Alley," a half-block south and parallel to present-day Broadway Avenue, is seen here around 1902. Retail businesses like Ferrell's and the Fair Store occupied the street level on the Broadway Avenue side, while around back, farmers brought their produce for processing and packing onto railcars. Ladies of the evening operated out of some of the furnished rooms upstairs between the two streets until at least the early 1960s. The three-story building is now an antique gallery. (Courtesy BCHS/MOI.)

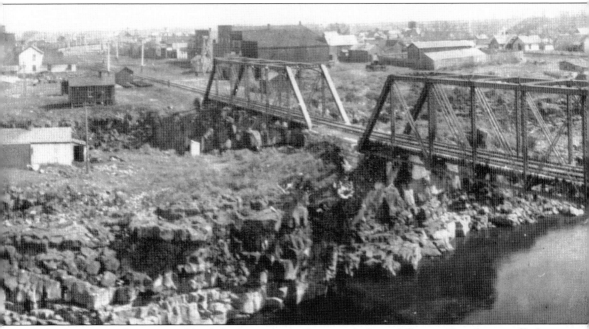

light district on the river and had the houses torn down and planted flowers. But the so-called "obnoxious element" quickly returned, and a "restricted district" was formed around the river a few years later. (Courtesy BCHS/MOI.)

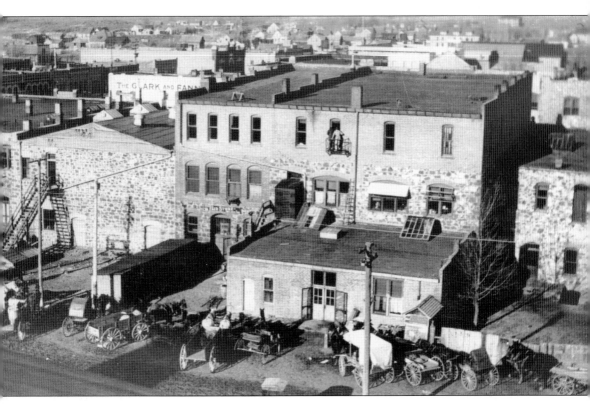

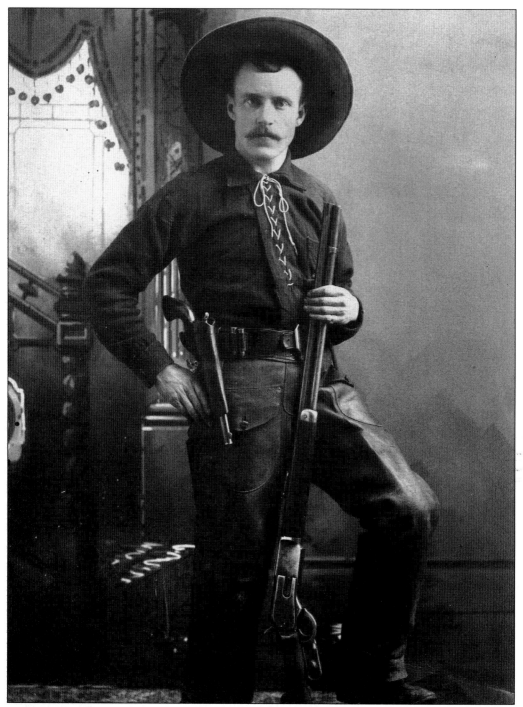

Eagle Rock and early day Idaho Falls was a wild western town where a facility with firearms amounted to a survival skill. Robert Winn displays some the tools of the trade and a rather serious outlook. He followed his adventurous brother Ed out West and operated a silver mine in Aspen, Colorado, which met with a fair degree of success. He joined Ed in Eagle Rock and opened a drugstore, then married a Pennsylvania woman and returned East. (Courtesy BCHS/MOI.)

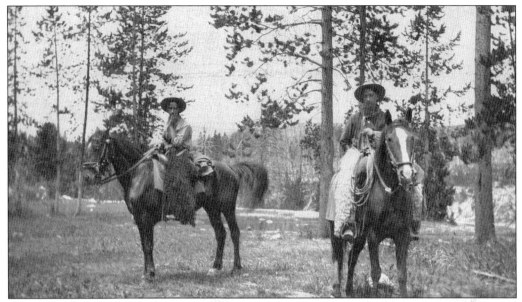

Young Frank and Fred Keefer are pictured here, but as they were twins, it is unclear who is who in this image. Fred served as a deputy under several sheriffs over a lengthy law-enforcement career. He joked that a big part of his job was to frequently arrest his brother Frank, a cowboy. (Courtesy BCHS/MOI.)

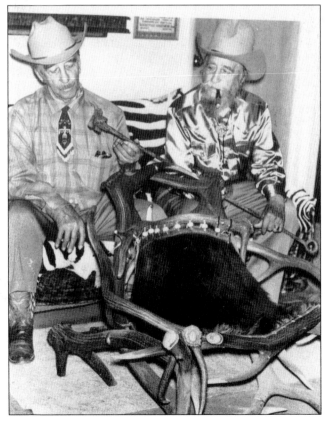

Fred (left) and Frank Keefer are seen here in later years. The twins were sons of pioneer builder W. W. Keefer. Frank collected memorabilia from Eagle Rock's earliest days, such as this elk antler chair, and displayed it in his home museum until his death. (Courtesy BCHS/MOI.)

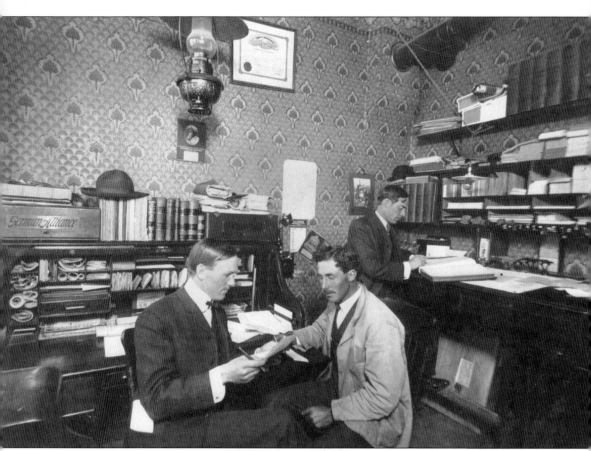

Working in this early Eagle Rock real estate or law office (note the law books in background) are two unidentified men and Louis A. Hartert (center). (Courtesy PR.)

Here is a horse-drawn fire engine, c. 1907, with Julius Marker at the reins. The apparatus cost $1,950 and replaced a man-drawn cart. Marker was appointed as the driver and later became the town's fire chief. In 1885, the town of Eagle Rock experienced a fire that burned nearly all of the frame shacks on Eagle Rock Street. This led to the beginning of the volunteer fire department. Volunteers were notified by ringing a large bell, now at the Bonneville County Museum. (Courtesy PR.)

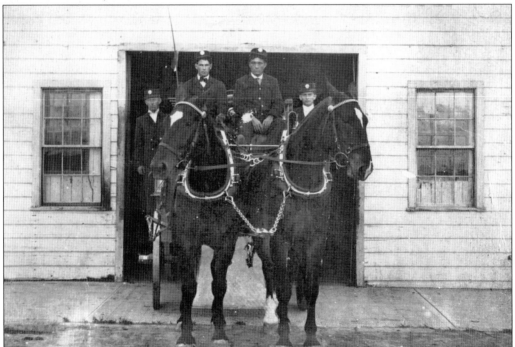

On September 11, 1904, a fire started in the Butte Bakery and Café on Broadway Avenue. Low water pressure hampered firemen, and the blaze spread until the business district north of Broadway Avenue and west of Park Avenue to the river was virtually burned to the ground. Nothing was left of about 20 businesses but ashes, including the new "restricted" district, and most of those left standing were damaged. By 1909, two men were paid by the city to man the equipment at a fire station, then located on Park Avenue, and the firemen had uniforms. (Courtesy BCHS/MOI.)

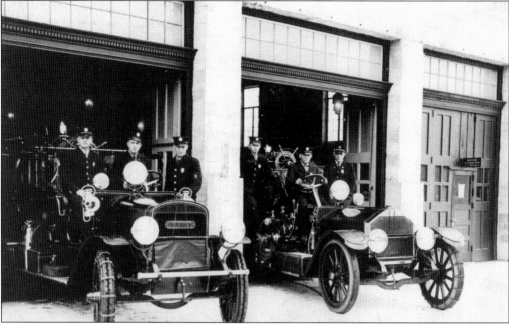

By the 1920s, Idaho Falls had two fire engines. Note the tire chains for winter traction. The city acquired its first motorized engine, a 1916 American LaFrance pumper, after a two-year fight, but by 1945, the department had three engines and 12 firemen. (Courtesy BCHS/MOI.)

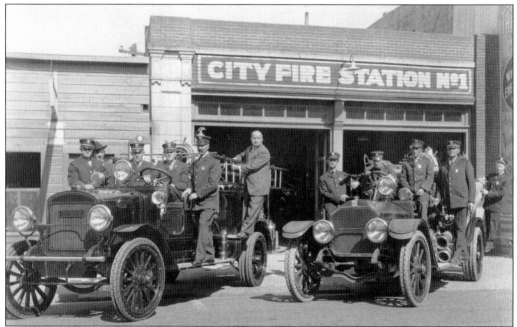

Around 1930, the fire department moved into city hall. During the same time period, the department bought a 1928 American LaFrance Hook and Ladder that was considered state-of-the-art equipment for its day. The department still ran the engine during Fourth of July parades until about five years ago. Efforts to restore it to running condition are underway. (Courtesy BCHS/MOI.)

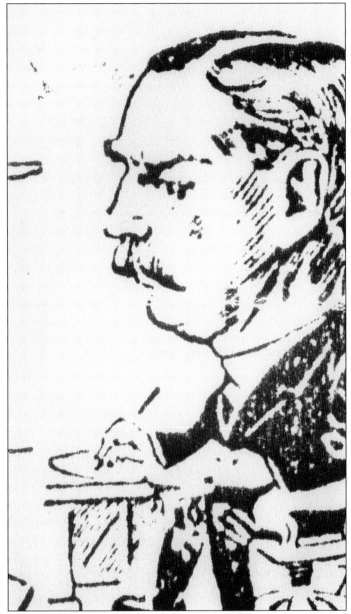

This is a sketch of crusading Mayor D. G. Platt, elected with the support of the Civic League in 1907 during a wave of reform. One of the town's three newspapers, the *Times*, printed a series from the Civic League of Idaho Falls that was supposedly non-partisan but backing Platt. "It is well-known that an enormous corruption fund has been collected for the saloons, breweries, gamblers and the immoral contingent on the river front," the league proclaimed on March 5. "Two newspapers have already been subsidized to do the bidding of the morplots in the personal abuse of respectable citizens." The Civic League labeled Charles Sumner's *Post* as "the major organ of the so-called Progressive Party" and questioned the Republican purity of the *Register*. Though the *Times* repeatedly claimed that the Civic League was "not a political party," when Platt won, the new mayor immediately appointed a new police chief and three officers, along with several other city posts. The *Times* was made the official paper of the city. (Courtesy BCHS/MOI.)

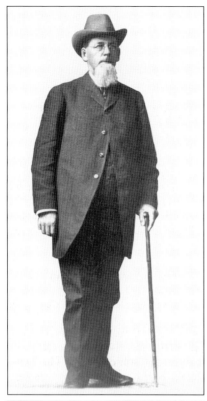

Newspaper publisher William E. Wheeler founded the *Register* in 1880 at Blackfoot. At first, Wheeler's paper had little but disdain for the rowdy outpost to the north. Blackfoot was the seat of an enormous county and the town nearest the Fort Hall Indian Reservation, but it lost a bid to be the territorial capital and was bypassed as the Idaho headquarters of the Utah and Northern Railroad, which went to Eagle Rock instead. Wheeler moved his paper north in 1884. (Courtesy BCHS/MOI.)

This photograph of the old *Register* composing room shows pots of lead heating on the stove at left, printers at work setting sticks of type, and a compositor standing over a partially composed page. Publisher William Wheeler tried to buy the most modern equipment available for his paper, but he had trouble holding onto compositors, many of whom were "gypsy printers" passing through on their way to elsewhere. (Courtesy PR.)

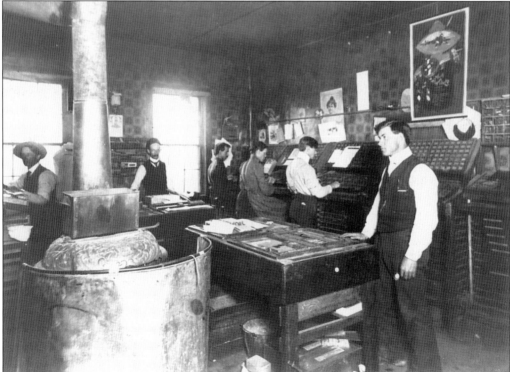

Three

A FRONTIER NEWSPAPER

Being a self-appointed critic in a lawless frontier town required great personal courage, standing outside the front door of the newspaper each Saturday and handing out papers that were still wet from the presses, confronting those he had accused on a weekly basis.

In 1894, dapper newspaper publisher William E. Wheeler described a fizzled attempt to establish a stage line to St. Anthony: "Antone Edinger . . . brought a dilapidated old worn-out coach and a few skinny horses and made no attempt to run a stage line. He knows about as much about stage lines as a hog does about music."

The following year the *Register* reviewed the Independence Day arrival of a traveling circus. "Idaho Falls was visited on Friday last by the most gigantic fake and gang of surething gamblers, thieves and pickpockets that ever spread a tent in this city . . . the only redeeming virtue being their good horses."

In 1890, the *Register* faced competition from the *Idaho Falls Times*, a brash newcomer run by Sam Dennis and Rufus Bonney. But hard times struck, and in 1891, the *Times* announced it was "ready to receive grain, potatoes, wood or anything else it can use, on subscription." The *Times* suffered a blow when it lost a $3,000 libel judgment to a county court clerk and passed through a series of ownership changes.

The competitors were often at odds. Wheeler's *Register*, usually an ardent booster for change, waged a bitter fight against the city's first power plant, urging the city to concentrate its resources on improving the town's water system. The *Register* stubbornly declined to notice when electric lights came on for the first time in 1900.

A third newspaper arrived in 1905 when a dashing young newspaperman from Colorado, Charles Sumner, established the *Idaho Falls Daily Post*. To meet the competition, the *Register* began twice-weekly publication on June 2, 1908, and then merged with the ailing *Times* in 1920 so that it too could publish a daily edition, the *Times-Register*.

In its early years, the *Post* was the innovator, offering full-color Sunday comics and filling its columns with yarns about white slavery, runaway brides, gory accounts of suicides, and murder trials. By 1918, the *Post* was proclaiming itself as "the only Idaho daily with full leased wire, publishing both morning and evening editions."

That year, a Midwestern newspaperman, J. Robb Brady Sr., came to Idaho to help settle the estate of his father, former governor James H. Brady, who died while serving in the U.S. Senate. In 1925, Brady purchased the *Post*. In less than a year, Brady died at his desk of heart failure but not before he had hired E. F. McDermott from Boise. McDermott ruled the paper for 50 years, first as general manager and later as publisher.

It became apparent that the agricultural area in the grip of the Great Depression couldn't support two daily newspapers, and McDermott engineered the merger of the *Post* and the *Times-Register*. The last remnant of the feisty old *Times* was dropped from the masthead, and the newspaper became the *Post-Register* with a combined circulation 4,550 in 1931.

It was a period of growth and prosperity for the region and the paper. The Snake River Valley fulfilled its earlier promise and became a major producer of farm products and a world center for potato production. In 1949, McDermott and others, including noted Idaho Falls attorney William Holden, successfully wooed the fledgling atomic energy industry's national testing station to the Arco desert west of town.

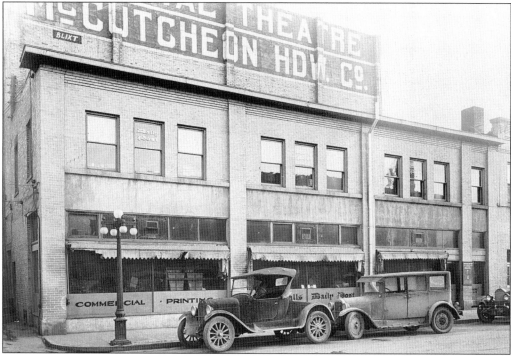

The *Daily Post* offices were here on A Street. In 1905, Charles Sumner arrived from Colorado with his brother Ernest, printer Henry Gabbe, and an ill-advised plan to start the town's first daily newspaper. Shortly after their arrival, the rival *Times* described the *Post* as a "trio of fledglings of recent importation (and) ludicrous literary efforts concerning persons and local conditions for which they know nothing." The Sumners sold out and moved on to Pocatello around 1910. (Courtesy PR.)

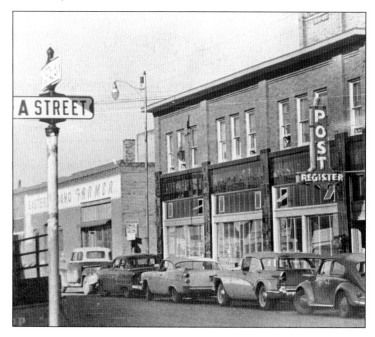

The *Post-Register* offices were originally located on Capital Avenue next to the *Eastern Idaho Farmer*, a weekly farm and political publication that lasted until the 1970s. In pre-radio days, crowds often lined up on the street outside the newspaper to get the latest World Series scores, posted on a large tote board. (Courtesy PR.)

Pioneer newsman Sam Dennis (right) was the first printer at the *Idaho Register* in 1884 and helped to start the rival *Times* in 1890 with Rufus C. Bonney. The *Times* lost a libel suit, and the paper's backers declined to pay the judgment, but George Chapin bought it at a bargain price. It struggled along under a series of owners. Dennis returned as business manager in 1915, but the ailing *Times* merged with its old rival, the *Register*, in 1920, and Dennis retired. (Courtesy PR.)

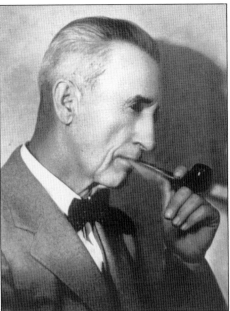

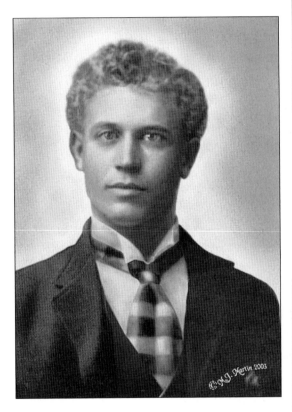

Charles Sumner (left) started the *Idaho Falls Daily Post* in 1905 after he was run out of Colorado by agents of the mining companies for sympathizing with labor organizers, according to Colorado historian Mary Joy Martin in her book *The Corpse on Boomerang Road: Telluride's War on Labor 1899–1908*. Sumner's arrival meant Idaho Falls had three newspapers, one a daily, in a town of 4,000 people. (Courtesy Mary Joy Martin.)

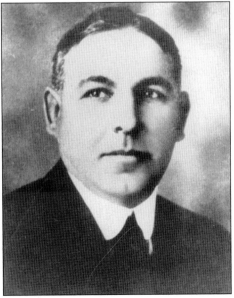

J. Robb Brady Sr. (right) came to Idaho to settle the estate of his father, but he stayed on and bought the *Post* in 1925. He died of a heart attack in 1926, leaving E. F. McDermott to operate the newspaper on behalf of the Brady family for 50 years. Brady's son, J. Robb Brady Jr., took over the paper in 1977, and grandson Jerry M. Brady still serves as the newspaper corporation's head. (Courtesy PR.)

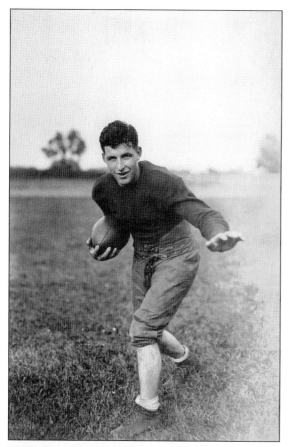

Jim Brady, J. Robb Brady's eldest son, was the quarterback of Knute Rockne's Notre Dame team that "won one for the Gipper" in 1928 in a game against Army. Brady returned to eastern Idaho in 1933 to help run the family newspaper business. Later he started KIFI-TV8. (Courtesy University of Notre Dame.)

E. F. McDermott ran the *Post-Register* for 50 years. He created the Goodfellow Fund, a two-week Christmas fund drive and a tradition the newspaper continues to this day. He was also instrumental in starting the Community Chest, which became the United Way, eastern Idaho's biggest nonsectarian charity. He celebrated the newspaper's 50th birthday in 1934 with a three-day Diamond Jubilee at the height of the Depression that brought thousands to town for parades, fireworks, rodeos, and even a beauty pageant. A practicing Catholic, he helped orchestrate construction of Sacred Heart Hospital, later Parkview, organized professional baseball in Idaho Falls, and later become Pioneer League president. (Courtesy PR.)

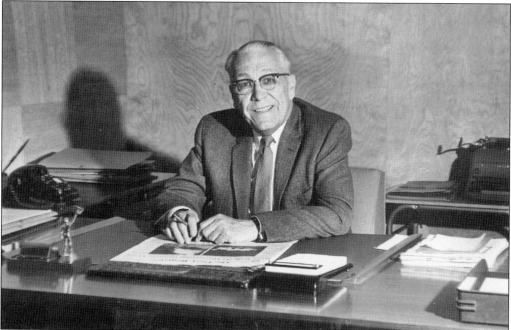

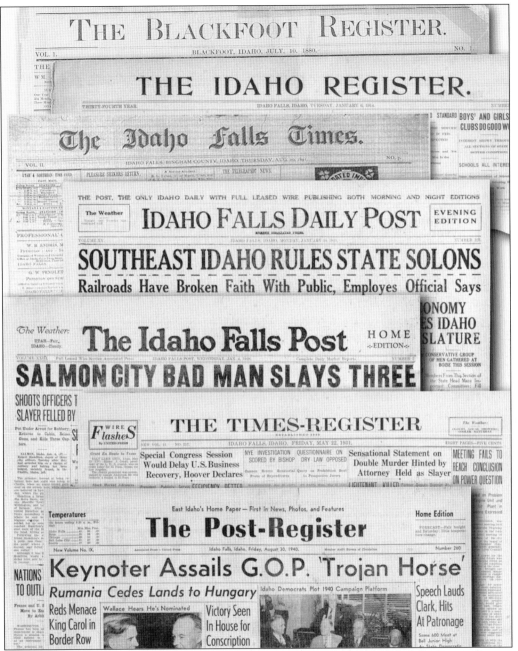

THE BLACKFOOT REGISTER.

VOL. 1. BLACKFOOT, IDAHO, JULY. 10. 1880. NO. 1.

THE IDAHO REGISTER.

THIRTY-FOURTH YEAR IDAHO FALLS, IDAHO, TUESDAY, JANUARY 6, 1914.

BOYS' AND GIRLS
CLUBS DO GOOD W

The Idaho Falls Times.

VOL. II. IDAHO FALLS, BINGHAM COUNTY, IDAHO, THURSDAY, AUG. 8th, 1891. NO. 3.

SCHOOLS ALL INTERE

THE POST, THE ONLY IDAHO DAILY WITH FULL LEASED WIRE PUBLISHING BOTH MORNING AND NIGHT EDITIONS

The Weather

IDAHO FALLS DAILY POST EVENING EDITION

SOUTHEAST IDAHO RULES STATE SOLONS

Railroads Have Broken Faith With Public, Employes Official Says

ONOMY
ES IDAHO
SLATURE

The Weather:
UTAH—Fair,
IDAHO—Cloudy.

The Idaho Falls Post HOME -EDITION-

SALMON CITY BAD MAN SLAYS THREE

SHOOTS OFFICERS T
SLAYER FELLED BY

THE TIMES-REGISTER

F WIRE lashes By UNITED PRESS

IDAHO FALLS, IDAHO, FRIDAY, MAY 22, 1931.

EIGHT PAGES—FIVE CENTS

Special Congress Session
Would Delay U.S. Business
Recovery, Hoover Declares

NYE INVESTIGATION QUESTIONNAIRE ON
SCORED BY BISHOP DRY LAW OPPOSED

Sensational Statement on
Double Murder Hinted by
Attorney Held as Slayer

MEETING FAILS TO
REACH CONCLUSION
ON POWER QUESTION

Temperatures

East Idaho's Home Paper — First in News, Photos, and Features

Home Edition

The Post-Register

New Volume No. IX. Idaho Falls, Idaho, Friday, August 30, 1940. Number 260

NATIONS
TO OUTL

Keynoter Assails G.O.P. 'Trojan Horse'

Rumania Cedes Lands to Hungary

Reds Menace
King Carol in
Border Row

Victory Seen
In House for
Conscription

Speech Lauds
Clark, Hits
At Patronage

Idaho Falls had three competing newspapers from 1905 until 1920. The *Blackfoot Register* began in 1880 and changed its name to *Idaho Register* when it moved to Eagle Rock in 1884. The *Times* started in 1890. The *Daily Post* arrived in 1905 before dropping "Daily" when its rivals also began daily publication. The *Times-Register* combined in 1920, and the *Post-Register* merged in 1931. (Courtesy PR.)

The Wheelers lived and worked here in the original Register Building. After more than two decades, publisher William E. Wheeler sold part interest in the *Register* in 1907 and retired at age 65. He had also served as school board chairman, postmaster, and judge. By his death in 1919—run down by a delivery truck while taking his evening constitutional along Broadway Avenue—the newspaper had passed to other hands. (Courtesy PR.)

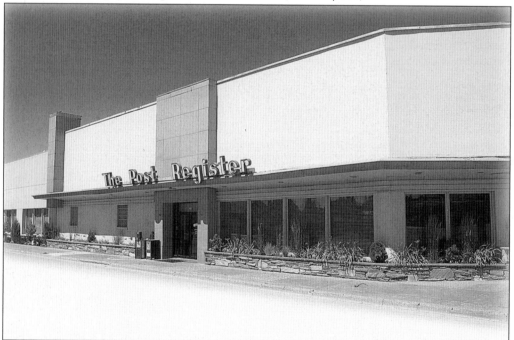

The *Post-Register* moved to its present site at 1800 Northgate Mile in 1959. Its Goss Urbanite presses were installed in 1978 and will be moved into a separate new $6 million production and packaging facility in 2007. (Courtesy PR.)

J. Robb Brady Jr. began as a reporter for the *Post-Register* and served as the newspaper's publisher from 1977 until 1989. During the 1950s, the newspaper, under Brady, was an unabashed booster of nuclear energy, tourism, agriculture, and growth. It championed the ill-fated Teton Dam, a flood-control project that was strongly opposed by environmentalists and which collapsed in 1976. Later on, Brady and the *Post-Register* became a leading voice for environmental and conservation concerns. (Courtesy PR.)

Under the leadership of Jerry M. Brady (great-grandson of U.S. senator James H. Brady and Democratic candidate for governor in 2002 and 2006), the paper became a seven-day-a-week morning newspaper in 1997. In 1998, he established an employee stock ownership trust, effectively selling 49 percent of the newspaper to its employees with the money for the purchase coming out of company profits. The paper is still locally owned and managed 125 years later. (Courtesy PR.)

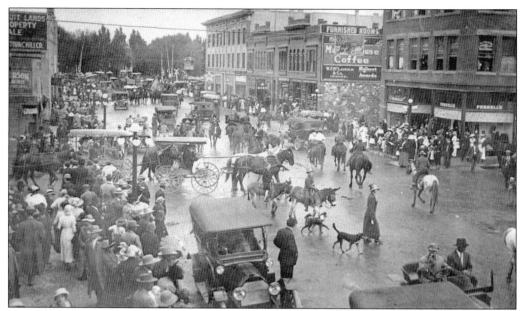

This view of Broadway Avenue looking east was probably taken around 1910, since the street was paved sometime after 1905 and the streetlights evident in the photograph were installed "six to the block" in 1909, with the poles paid for by business owners. Model T Fords, manufactured starting in 1908, shared traffic with horses, mules, and wagons. Ferrell's clothing store was located on Broadway Avenue in 1904; the building is now occupied as a newly renovated hotel, Destinations Inn. Ferrell's moved up the street to 417 Broadway Avenue around 1959. In this view, trees occupy the area along Elm Street where the Museum of Idaho now stands. Note the two women on mules in the lower center of the photograph. (Courtesy PR.)

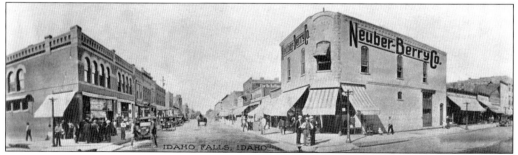

This panoramic view of downtown Idaho Falls faces north near the intersection of Broadway and Park Avenues. A few of the building details remain, including the distinctive front on the Neuter-Berry Company that identifies it as the original Clark and Fanning Company. A music store now stands there. (Courtesy PR.)

Four

EAGLE ROCK
BECOMES IDAHO FALLS

Plural marriage was a linchpin issue in 1889, when winning statehood had something to do with keeping members if the Church of Latter-day Saints (Mormons) away from the ballot box. The path to statehood ran right through Eagle Rock, with the activities of the anti-polygamy movement centered in eastern Idaho.

Mormons moved into the state in the 1860s, and it wasn't long before they built a strong coalition within the Democratic Party with their principles of economic and political cooperation. The communal Mormon ways and their past practice of polygamy created distrust among other factions in the territory. From 1885 to 1893, the Test Oath disenfranchised any Idahoan who belonged—or had recently belonged—to an organization advocating plural marriage.

"Tolerance was no virtue of the American Frontier, and Mormon principles had clashed in many important ways with the traditions of their contemporaries," wrote Merle Wells, who along with Merrill Beal authored a 1959 book on Idaho history. As statehood loomed ever closer, "Nothing less than incarcerating the Mormon leaders in the territorial prison and depriving all the rest of the Saints of any chance to vote, to hold office, or serve on juries . . . would satisfy the radical anti-Mormons of Idaho," Wells wrote.

At the time, much of Eagle Rock's trade came up from northern Utah by freight wagon or by rail. Mormon elder William Holmes Walker, one of the founders of the ZCMI store in Eagle Rock, recalled the warning he received from Ricks College founder and LDS patriarch Thomas E. Ricks:

> (20 October 1889) . . . At Ogden I shipped a quantity of furniture and at Logan a carload of flour to Lewisville. From Logan I traveled in company with Thomas E. Ricks, president of Bannock Stake. He had not been home more than a week before a general raid was made on all polygamists throughout the country. President Ricks made his escape through Teton Valley and National Park and headwaters of Missouri to England. Before leaving he sent word that I had better get out of the way. At first I did not see the necessity of hiding, as I had only one wife in Idaho. Finally I concluded that I would not ignore the advice of a friend.

After Idaho achieved statehood and the LDS Church disavowed polygamy, the issue died down quickly, along with the political careers of those who have pursued it.

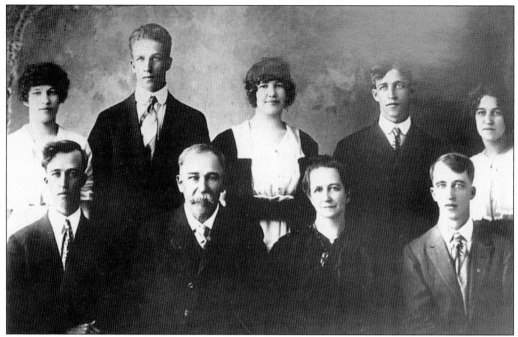

The Keefer family of Idaho Falls is posing here around 1918, before Frank Keefer left to serve in World War I. Pictured, from left to right, are (first row) Fred Keefer, father William Walker Keefer, mother Dorothy Virginia Shoemaker Keefer, and Fred's twin Frank; (back row) Louise Keefer Blackbird, Clyde Keefer, Ruby Brace, Phil Keefer, and Mrs. Claude (Irene "Dot") Black. (Courtesy PR.)

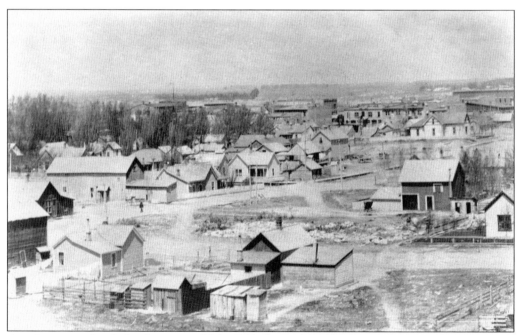

Another view of early day downtown Idaho Falls shows the self-sufficient homesteads of a frontier town replete with sheds for livestock, fuel, and feed. (Courtesy BCHS/MOI.)

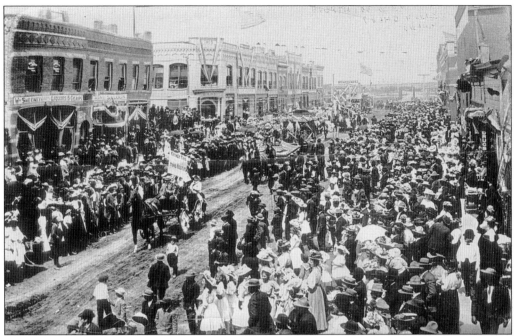
This is an Independence Day parade down Broadway Avenue taken sometime after 1905 (note the date on a building in the background) but before downtown streets were paved around 1910. (Courtesy PR.)

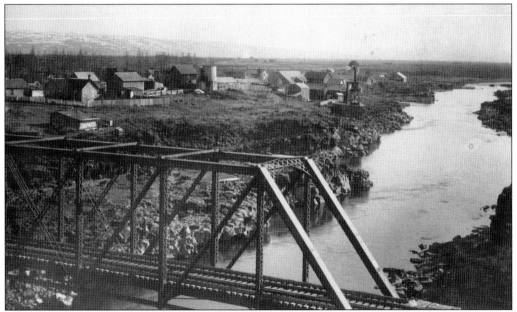
This view is of an unusually placid Snake River and a railroad trestle along the southern edge of Eagle Rock. During the annual spring runoff, the treacherous Snake River claimed many lives. (Courtesy BCHS/MOI.)

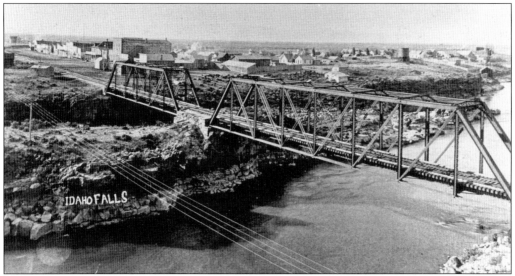

The location and layout of Eagle Rock's false storefronts are visible in this early photograph. (Courtesy BCHS/MOI.)

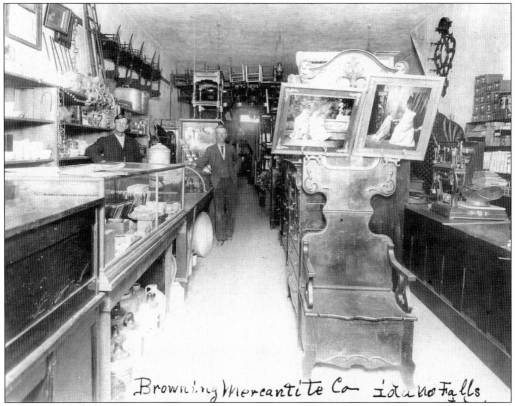

Browning's Mercantile was an early furniture store on Front Street (which was later renamed Broadway Avenue). The name change came about when local merchants invested in streetlights meant to illuminate the downtown area in the manner of the "other" Broadway in New York City. (Courtesy PR.)

Girls wade in the mud-bottom swimming pool at Highland Park. It was the city's first public park, created by John Lingren, a gatekeeper at Taylor's toll bridge. Lingren expanded it into an amusement park with a dance hall. Today the park is also the site of McDermott Field, home of the Idaho Falls Chukars Pioneer League professional baseball team. The city and private donations are funding plans to expand the baseball facility in 2007. (Courtesy BCHS/PR.)

Members of the Frew family, pictured here on horseback around 1926, include Kathleen, Robert, Jeanette, Anne, and Barbara. (Courtesy BCHS/PR.)

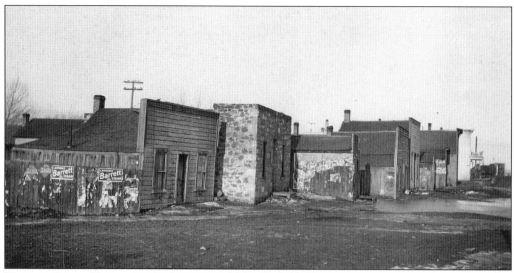

Here are the muddy, rain-washed streets and false-front buildings of early day Idaho Falls. Basalt, or lava rock (the center building), was a favored local building stone. Many downtown buildings today hide lava-rock foundations and walls behind brick or wood facades. (Courtesy BCHS/MOI.)

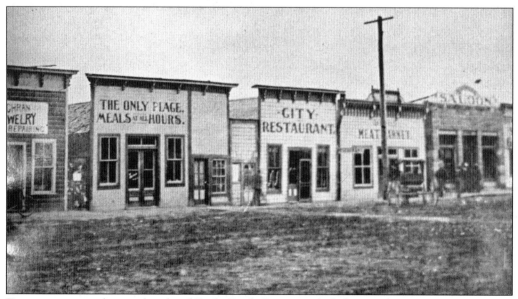

Frame stores on the south side of Eagle Rock Street included a jewelry store, meat market, restaurants, and saloons. (Courtesy BCHS/MOI.)

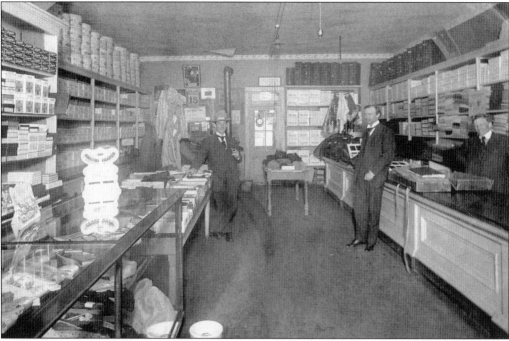

A typical dry goods store displays cravats, hats, luggage, and white dress shirts. (Courtesy BCHS/MOI.)

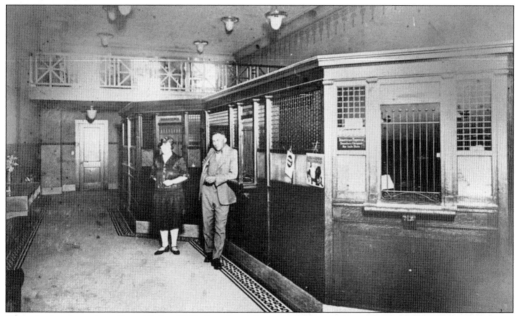

This is the interior of an Idaho Falls bank with wire teller cages and inlaid tile floor. Banking goes back as far as the town itself. When Matt Taylor and Robert Anderson opened their trading post on the banks of the Snake River in 1865, they were joined by Anderson's brother John, who established a private bank with his brother. Anderson Brothers Bank was chartered by the state of Idaho in 1893, was bought by Eccles Browning in 1927, and became a branch of First Security Bank in 1933. First Security merged with Wells Fargo in 2000. (Courtesy PR.)

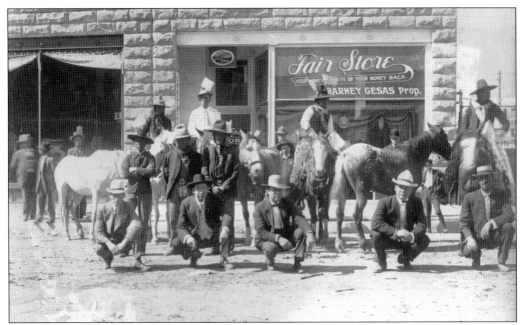

Drugstore cowboys pose on a dirt street in front of the Fair Store on Broadway Avenue, which used the phrase "your money's worth, or your money back," in a photograph that was probably taken around rodeo time. The unpaved street and lack of streetlights indicate it was likely taken prior to 1910. (Courtesy BCHS/MOI.)

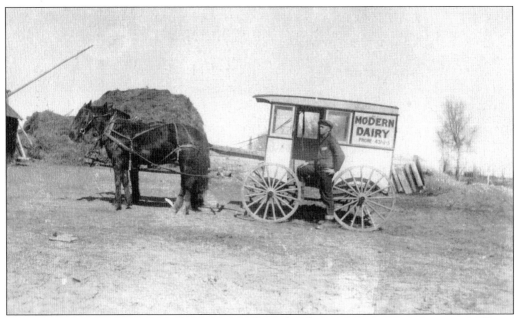

Louis Gohr, a routeman for Modern Dairy, takes a break. Dairies were an important industry in the upper valley, with millions of pounds of butterfat shipped from Idaho Falls. (Courtesy BCHS/MOI.)

Champion of the radical anti-Mormon movement was a territorial U.S. marshal, Frederick Thomas Dubois, whose family had close ties with both William Henry Harrison and Abraham Lincoln. Dubois used his connections to get support for a bill making Idaho the 43rd state in 1890. To pave the way, Dubois rounded up polygamists and, as a Republican U.S. senator, fanned the anti-Mormon fires long after it became a nonstarter politically. Dubois, who had the eastern Idaho town and one in Wyoming named for him, became the youngest member of the U.S. Senate at age 40. In 1907, he lost his final senate bid, running as a Democrat, to William E. Borah before serving as Woodrow Wilson's western campaign manager in 1912 and 1916. The self-proclaimed "Father of Idaho" died in Washington, D.C., on February 14, 1930, and is buried in Blackfoot. The midwinter funeral was largely an outside affair, with well-wishers lined up around the block outside his modest Blackfoot home. The presiding Episcopal priest had asked LDS officials to allow services at LDS Stake Center, but they declined according to historian William Pettite. This 1890 photograph, taken about the time Idaho joined the Union, shows a young Dubois. (Courtesy Idaho State Historical Society.)

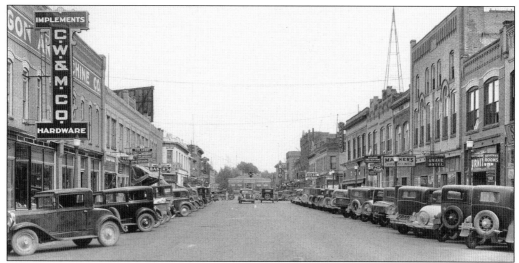

This is a 1930s view of Broadway Avenue looking east. By then, the Cooperative Wagon and Machine Company had moved downtown. The Carnegie Library at the end of the street (now the Museum of Idaho) was finished in 1916. (Courtesy BCHS/MOI.)

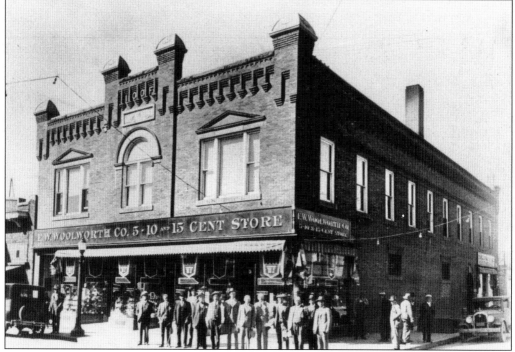

A fixture of turn-of-the-century small-town life, the Woolworth's in Idaho Falls occupied the International Order of Odd Fellows Lodge, which met upstairs. (Courtesy BCHS/MOI.)

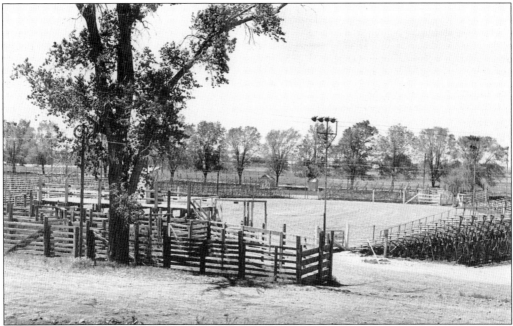

Beginning in 1912, War Bonnet Round-Ups were held at the arena and corrals of Tautphaus Park. Organizers tried to stage a fictitious Battle of War Bonnet to celebrate the creation of Bonneville County the year before. The plan was for 100 Indians, led by a fictional Chief War Bonnet, to attack a stagecoach defended by cowboys, but it was canceled when the Native Americans refused to participate. (Courtesy BCHS/MOI.)

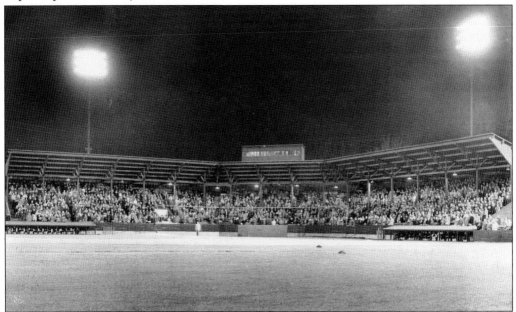

The opening game at Highland Park in 1950 drew a packed house. When the old bleachers burned down, new ones were erected in 1977, and the field was renamed to honor longtime *Post-Register* publisher and former Pioneer League president E. F. McDermott. McDermott died the same year. (Courtesy BCHS/MOI.)

A group called Save Eagle Rock tried to preserve four buildings along the city's original business district from demolition in 1973. The effort failed, but a new development just across the river on the city's west side, called Taylor's Crossing, promises to recreate much of the flavor of the downtown's past. (Courtesy BCHS/MOI.)

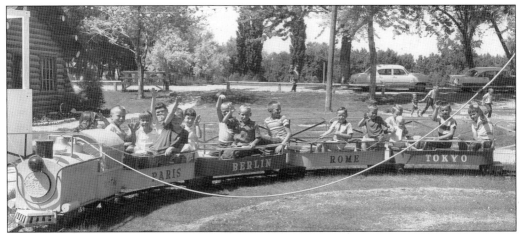

Children ride a train at Tautphaus amusement park around 1957. Many of the rides still operate. (Courtesy BCHS/MOI.)

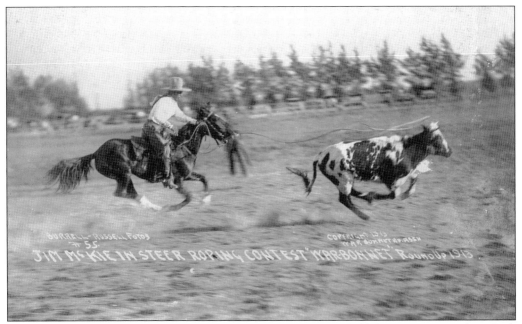

Jim McKie ropes a steer during the 1913 War Bonnet Round-Up held that year at Tautphaus Park arena. Early roundups were held in the afternoon at what were then the county fairgrounds, but the rodeo was suspended during World War I and some of the Depression years. It was restarted after World War II and moved to Sandy Downs south of the city in 1970. (Burrell-Russell photograph; courtesy BCHS/MOI.)

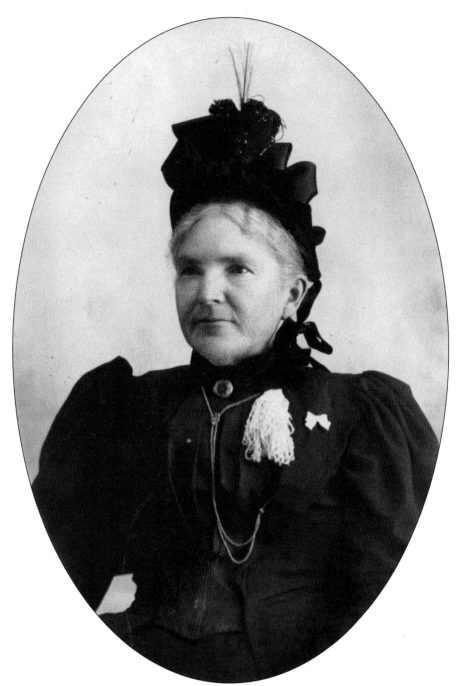

Rebecca Mitchell started toiling for women's suffrage in the state in 1891. At the polls, she and other women hired boys to carry placards saying "Vote for your Mothers." While few men voted on the measure, a majority of those who did supported women's suffrage. In 1896, the legislature appointed her its chaplain. She worked hard at the job, preaching to state prison inmates and securing a parole law. Though health problems restricted her during the last years of her life, Rebecca Mitchell always kept up with current events and wrote a history column for the *Times*. She died at age 74 in Idaho Falls from tuberculosis. (Courtesy PR.)

Five

CIVILIZATION COMES BY TRAIN

It was through Rebecca Brown Mitchell that Idaho Falls gained its first church, library, and school. She was an ardent women's rights supporter and the legislature's first woman chaplain. Mitchell was widowed at 23 in 1858. The experience of having to buy back all her possessions after her husband's death stayed with her as a reminder of the lack of women's rights.

Once her sons were raised, Mitchell attended a Baptist missionary school in Chicago and then headed west with her daughter as a self-supporting missionary. Mitchell found Eagle Rock to be a dusty, shadeless town with a saloon but no church or school. She had to set up housekeeping in a shanty, which became a modest chapel and school. Mitchell rounded up enough money to have a church built in 1884. It served as a classroom during the day and a library at night. Mitchell took instruction to learn how to teach and received a certificate. Daughter Bessie Mitchell collected money from residents to pay the freight on a shipment of Bibles and magazines sent from her mother's friends in Iowa to begin the town's first library.

Once her daughter was married, Mitchell became active in state matters. She was president of the local and state Women's Christian Temperance Union. In part through her work, the legislature passed a bill raising the age of consent for girls from 10 to 18.

The Eagle Rock School District formed and built the one-room Central School at Eastern Avenue and Elm Street in December 1882, the same year Mitchell arrived. On August 5, 1892, the cornerstone was laid for a new eight-room Central School building on Water Street.

In 1894, Idaho Falls No. 1, the first independent school district, was formed and a high school was established. The district reported 153 students. The following year, it held an election for a six-mill school district property tax. On April 12, 1912, a new high school was slated for the 600 block of South Boulevard, completed in 1916. Emerson grade school was completed in February 1920. Another building went up in 1930, and the two became one school in 1946. Also in 1930, the south part of O. E. Bell Junior High was built on Ridge Avenue where Central School was located. It closed in the spring of 1981. Hawthorne Elementary was dedicated on November 11, 1937, at 1520 South Boulevard.

A building boom started in 1952 with the completion of Idaho Falls High School. Between 1954 and 1965, eight of the district's 12 elementary schools were built. The district also erected Skyline High in 1968. Bonneville Joint School District 93 was created in 1950 for the outlying areas of Bonneville County. Attendance in that district has mushroomed since 2003. But enrollment in the Idaho Falls School District has been slipping since 1994, and the decline is expected to continue until at least 2010.

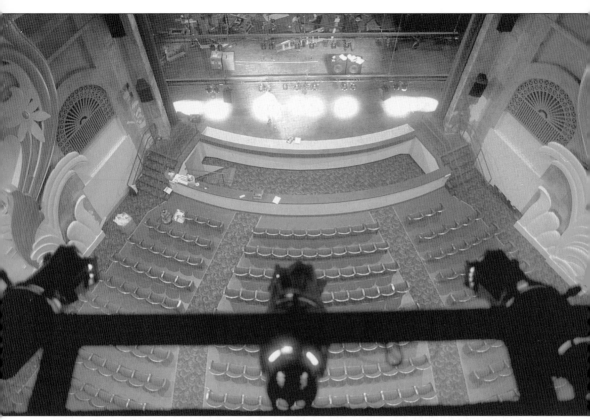

This is the refurbished interior of the Colonial Theater on A Street. It was built in 1919 for $50,000 and was home to traveling vaudeville acts and such musical entertainers as Fred Astaire and John Philip Sousa. It closed in 1980 and was reopened in 1999 as the home of the Idaho Falls Arts Council, complete with galleries and 970 seats, coordinating a year-round schedule of concerts and visual performing arts. The theater currently draws touring national acts and rents its stage to local performing groups. Several other organizations serve the town, including the Actor's Repertory Theatre of Idaho, Anam Cara, Ballo Capesso, the Bonneville Art Association, and a local Colored Pencil Society of America chapter, in addition to the Eastern Idaho Photographic Society, Rainbow Dragon School of Fine Arts, Idaho Falls Community Concert Association, and others. (Courtesy PR.)

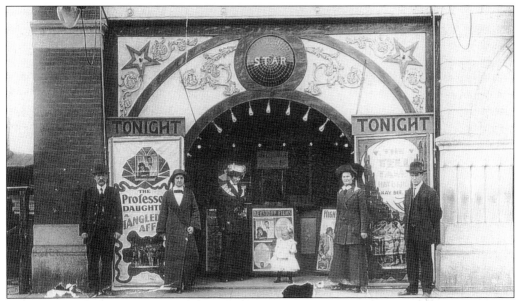

This is a vaudeville troupe outside the Star Theater. Other downtown diversions included two nickelodeon theaters, plus the Dime (the city's first theater, built in 1908), the Scenic, the Gayety, and the Colonial (built in 1919). Sometimes early theatergoers got more than they bargained for. Actress Mona Delayn, who billed herself as "The Bullet-proof woman," performed her act at several local theaters during the summer of 1914 but was shot dead on the stage of the Rex Theater during a performance on October 16. Her partner, a Mr. Hobbs, was arrested and remarked to police that it was their first accident in nine years. (Courtesy BCHS/MOI.)

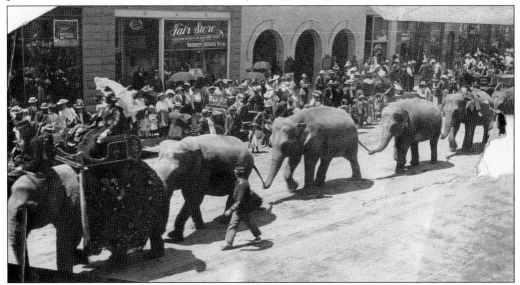

Elephants parade along Broadway Avenue's unpaved street to announce the annual arrival of the circus. On July 6, 1906, a visit by the Sells-Floto Circus resulted in excitement when five elephants broke free and took a dip in the nearby Snake River. Two elephants then proceeded downtown, wandering along the sidewalks and peering into the State Bank Building before being rounded up. The circus paid for damages, and no one was injured, including the elephants. (Courtesy BCHS/MOI.)

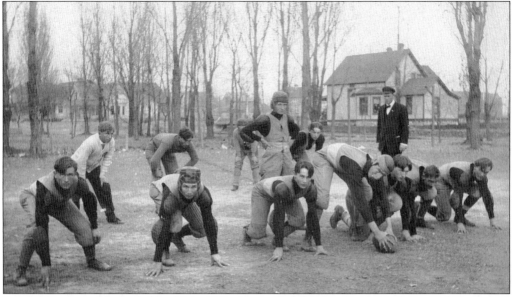

Football practice is being held at Idaho Falls Central High School at Sixth Street and Boulevard. It was a high school until 1952 and served as a junior high school until it burned down on April 24, 1973. (Courtesy BCHS/MOI.)

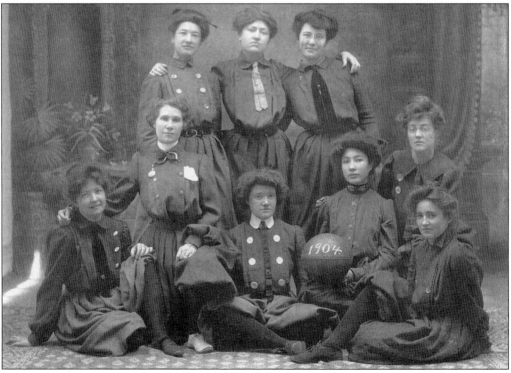

Seen here is the 1904 Idaho Falls Central High School girls' basketball team. The first graduate of the Idaho Falls High School was Blanche Wierman in 1899. Four received diplomas in 1900 but none matriculated in 1901. On May 22, 1903, four students graduated from the high school. Two years later, the school graduated 13 students. (Courtesy BCHS/MOI.)

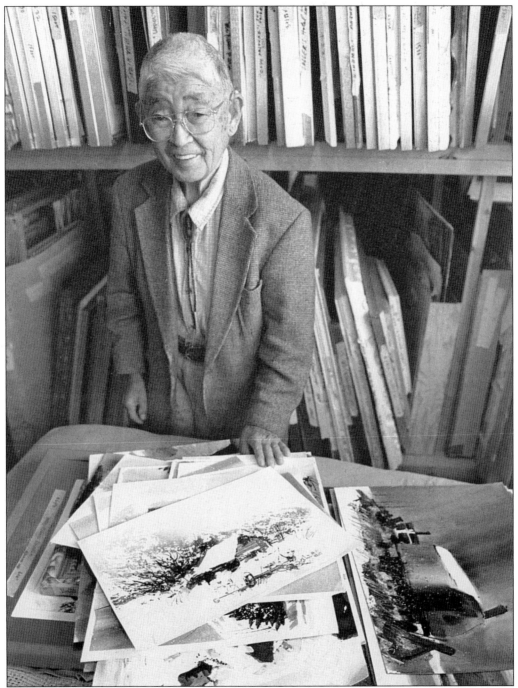

Idaho Falls artist Fred Ochi, one of four founders of the Eagle Rock Arts Guild, poses with some of his signature "Red Barn" watercolors. Ina Oyler, Ochi, Suzanne Fonnesbeck, and Helen Aupperle created the guild in 1948. The group grew over the years, attracting new and enthusiastic members to the various venues that housed it. In 2002, the guild established the Eagle Rock Art Museum as a permanent home. The guild puts on the annual Sidewalk Art Show, a spring show, and a holiday show. (Courtesy PR.)

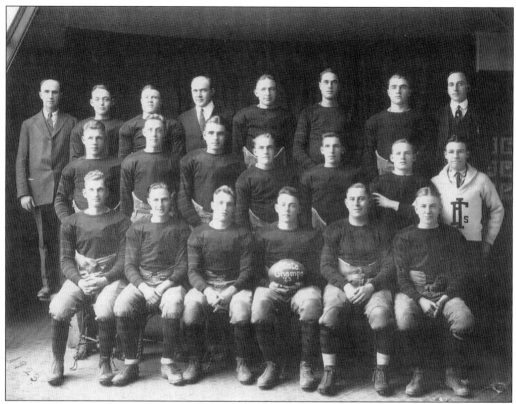
The 1923 Idaho Falls High School football team were state champions. (Courtesy BCHS/MOI.)

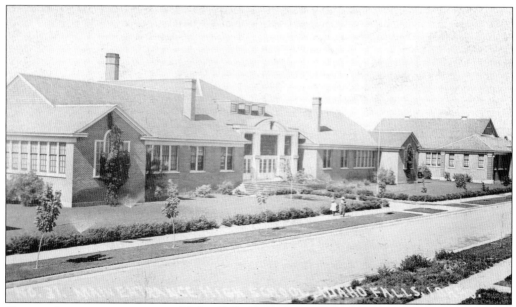
Here is the main entrance to Idaho Falls High School on Sixth Street and Boulevard. (Courtesy BCHS/MOI.)

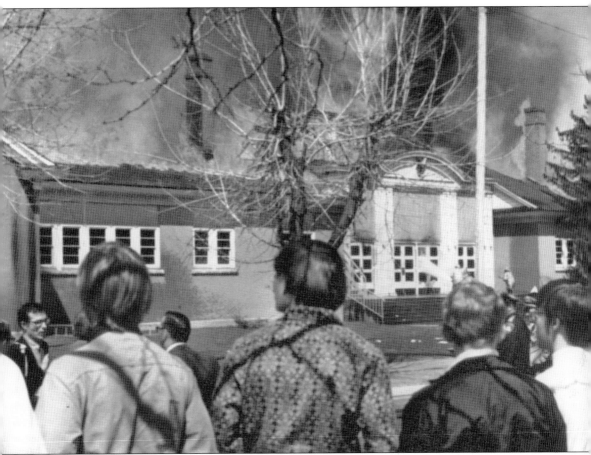

The town's first high school was serving as a junior high when it burned down on April 24, 1973. (Courtesy BCHS/MOI.)

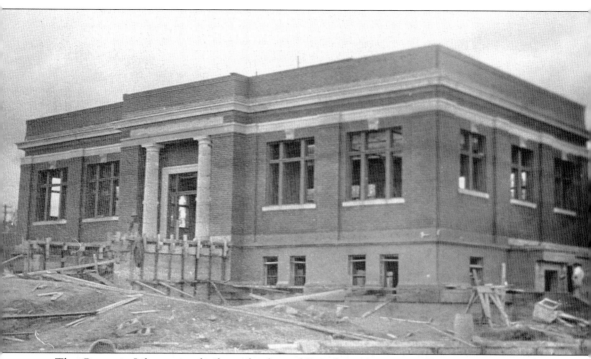

The Carnegie Library was built at the foot of Broadway Avenue, at Eastern Avenue and Elm Street, beginning in 1914 and was completed in 1916. The town's first permanent public library came about through a $15,000 grant from steel manufacturer and philanthropist Andrew Carnegie in the early 1900s, one of about 1,700 Carnegie libraries built in the United States until his death in 1919. When the library opened, its shelves contained 2,000 books, 60 magazines, and 8 newspapers. There were 420 cardholders. Marion Orr was the librarian from 1917 to 1954. In 1977, the Carnegie Library, or Idaho Falls Public Library as it had become known, was replaced by a new media center at Broadway and Capital Avenues, where the center of old Eagle Rock was located. The new library was built with a $2.6 million bond passed by residents in 1974. In 1983, the Carnegie Library was added to the National Register of Historic Places, and two years later, the Bonneville Museum moved into the building and still resides there, now as the Museum of Idaho. (Courtesy BCHS/MOI.)

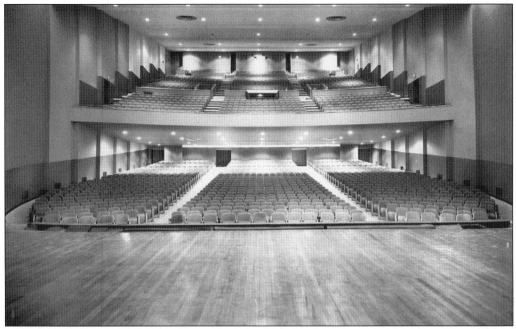

The Idaho Falls Civic Auditorium was built in 1952 as part of the new Idaho Falls High School on Holmes Avenue. As the largest auditorium in the area, the Idaho Falls Arts Association recently announced plans to book its larger shows there rather than at the smaller Colonial Theater. (Courtesy BCHS/MOI.)

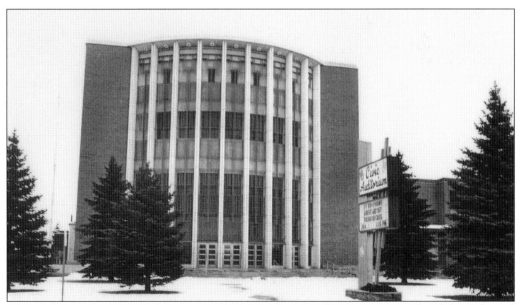

This is an exterior view of the Civic Auditorium where graduation exercises for Idaho Falls and Skyline High Schools are held. The auditorium is attached to Idaho Falls High School on Holmes Avenue. (Courtesy BCHS/MOI.)

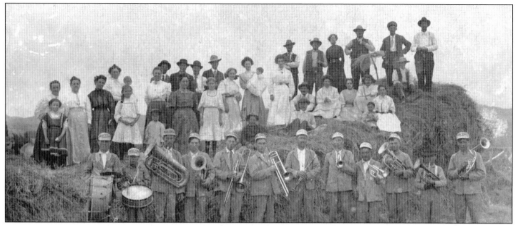

The Sand Hill Band is pictured on August 13, 1909. Community band competitions were popular in the 1910s and 1920s. Two institutions in particular have had a powerful influence on the growth of music and music study. In 1912, the Idaho Falls Music Club was organized, and in 1915, Horace Chesbro began tuning and selling pianos. (Courtesy PR.)

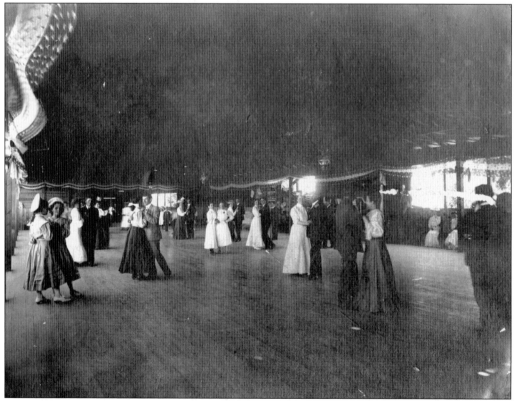

Idaho Falls received its first bandstand and dance pavilion in October 1893, when toll bridge gatekeeper John Lindgren donated Highland Park to the city. Church groups and organizations met at the bandstand in the middle of the park for picnics, reunions, and other get-togethers. Couples danced in the pavilion to music supplied by a windup gramophone. (Courtesy PR.)

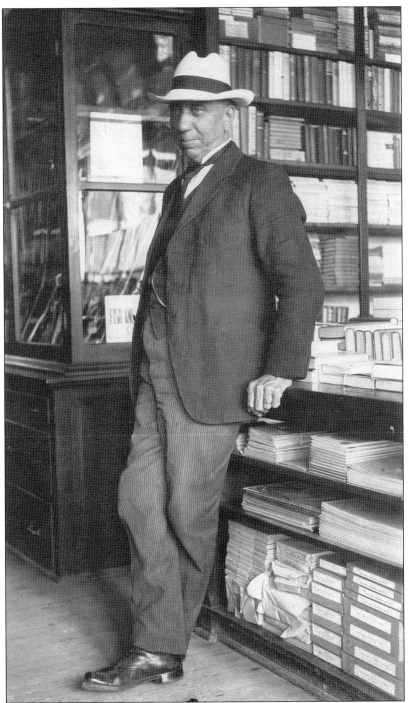

Musician, orchestra leader, and music-store proprietor Alma Marker built a home on Cliff Street and stocked the front room with musical instruments such as accordions, flutes, guitars, banjos, and mouth organs. He fiddled at dances for many years, and eventually the music store outgrew Marker's home and flourished as a valley institution on Broadway for many decades. Marker's store featured a wide array of sheet music and instruments. (Courtesy BCHS/MOI.)

Horace Chesbro and son Henry deliver a concert grand piano to the LDS Stake. The pair unloaded pianos from a railroad car and sold them door to door beginning in 1915. Later they branched out into band instruments and phonographs. In 1925, there were no bands in Idaho Falls area schools, so Chesbro Music Company hired band teachers to establish school music programs in several towns, including Rexburg and Idaho Falls. Around 1925 to 1929, Chesboro promoted, taught, and uniformed the first Chesbro Schoolboys' Band and marched in parades, and participated in other events. Eventually the Idaho Falls schools hired A. L. Gifford, a great organizer and showman, to head their music department. Gifford went on to direct the Idaho Falls High School Band for 36 years. (Courtesy PR.)

Chesbro's on Broadway is not only one of Idaho Falls' oldest surviving businesses, but it is the largest distributor of sheet music in the western United States. Horace and Ella Chesbro built their first store in 1918, with living quarters on the second floor, before moving to the present location on Broadway Avenue in the mid-1920s. (Courtesy PR.)

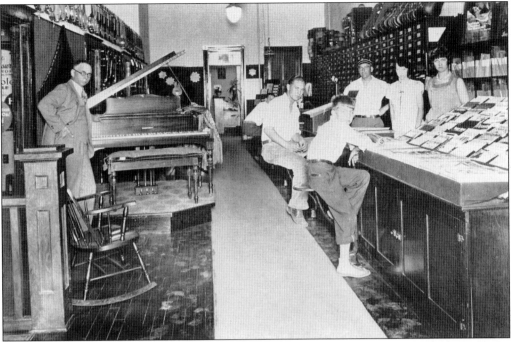

In the 1950s, kids turned their backs on grand pianos in favor of browsing the latest vinyl 45s. (Courtesy PR.)

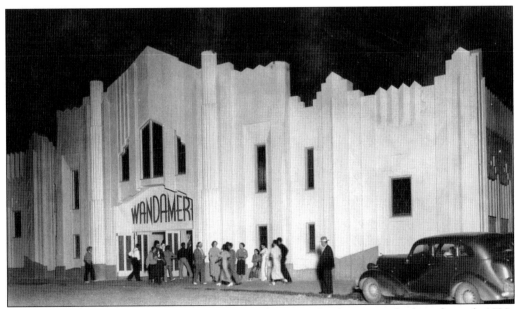

The Wandamere Dance Hall on Yellowstone Highway south of town was built in the early 1930s by Roland Beazer, who had built the Riverside Gardens earlier. Music and dancing was important to early day Idaho Falls. In the 1970s, the late Ruth Barrus, professor of music and humanities at Ricks College, conducted a three-year study in order to document the musical heritage of 23 communities in the Upper Snake River Valley. Her findings are preserved in a collection of videotapes and in writing. (Courtesy BCHS/MOI.)

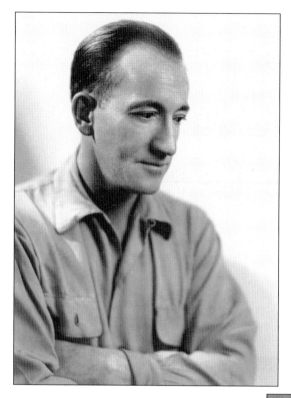

Noted Eastern Idaho author Vardis Fisher, pictured here in 1941, was born at Annis in 1895 and was hailed during the Depression as one of the most promising authors of the American West. He was ranked alongside his friend Thomas Wolfe, with whom he taught at New York University; William Faulkner; and Ernest Hemingway. Fisher won the Harper Prize and taught Wallace Stegner at the University of Utah. Fisher's work was published in French, German, Italian, Spanish, and Danish, and he wrote some 50 short stories and essays for magazines. His book *Mountain Man* was adapted into the movie *Jeremiah Johnson*, starring Robert Redford. (Courtesy BCHS/MOI.)

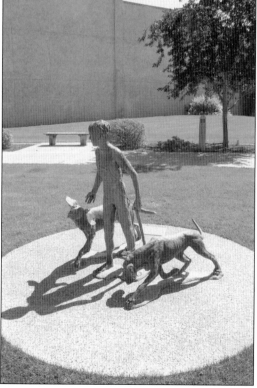

A statue outside the Idaho Falls Public Library honors author Wilson Rawls, who came from Oklahoma and married his wife, Sophie, in Idaho Falls in 1958. He lived in a home on Eleventh Street until 1976, and it was here that he wrote two books, *Where the Red Fern Grows* and *Summer of the Monkeys*. The first book has been ranked alongside *Call of the Wild* as one of the best dog stories ever written and has been adapted to film twice. Sophie Rawls established a scholarship fund to honor her late husband, and at least one Idaho Falls student has won the annual $1,000 scholarship. (Courtesy PR.)

Six

CHURCHES ARRIVE EARLY

Although Church of Jesus Christ of Latter-day Saints members began settling the Snake River Valley as early as 1855, they were not the first to come to southeastern Idaho on a mission. On Sunday, June 11, 1882, in a shanty that had formerly housed a saloon, newly arrived Baptist missionary Rebecca Mitchell conducted the first Sunday school and the next day organized a day school for the children. Those of other faiths were welcomed at the Baptist worship services, and on April 29, 1891, eight members decided to organize the First Presbyterian Church. The Presbyterians held separate services at the Baptist church until they could construct their own building at the corner of Shoup and A Streets.

St. John's Episcopal Church was organized on August 12, 1881, and members worshipped at each other's homes or held services during the week at the Baptist church. By 1895, the membership had grown to 30 families who erected a red brick chapel at the corner of Park Avenue and A Street. The church remained a mission until January 1953, when it became self-supporting.

Alliance Covenant Church had its beginnings in Idaho Falls on July 30, 1895, when a group of Swedish families met to start a Swedish-language church west of town. In March 1899, a newly arrived group of Swedish people organized the Swedish Evangelical Mission Church of Idaho Falls. A building was erected at Sixth Street and Boulevard in 1906, and in 1928, the two congregations merged. In the 1930s, the church switched from Swedish to the English language. By 1981, the church had become part of the Christian and Missionary Alliance and the name was changed to Alliance Covenant Church.

St. John Evangelical Lutheran church began as a mission program in 1902. In 1922, a small frame church was built on the corner of Seventh Street and Emerson where the brick church now stands. Eleven years later, the congregation was accepted into the Missouri Synod.

The September 10, 1934, edition of the *Post-Register* documents the Salvation Army's early work with the indigents and transients of Idaho Falls. "During the past winter the post served meals to hundreds each month, the number of meals served often approaching the 1,000 mark," it read. At that time, regular church services were held at the corner of Capital Avenue and C Street. A Ladies' Home League, a young people's group, and a Sunday school were also part of the post's religious offerings.

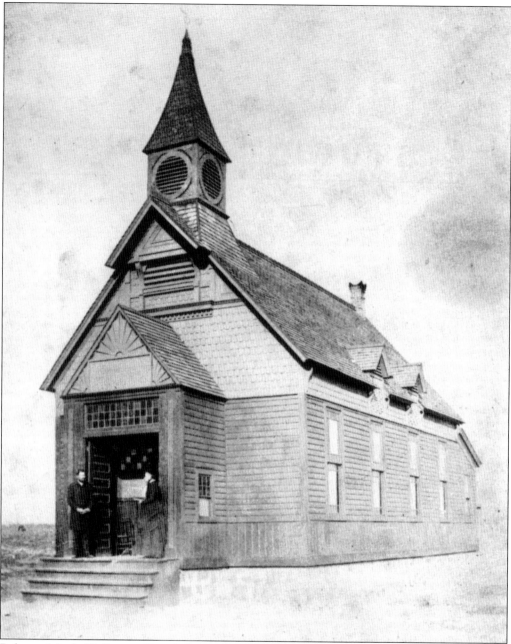

Rebecca Mitchell's Baptist Church, built in 1884, was Eagle Rock's first house of worship and was located on the corner of Eastern Avenue and Ash Street. (Courtesy BCHS/MOI.)

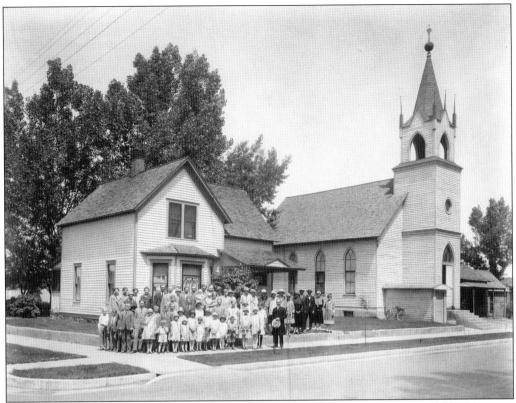

The congregation stands in front of the First Lutheran Church. (Courtesy BCHS/MOI.)

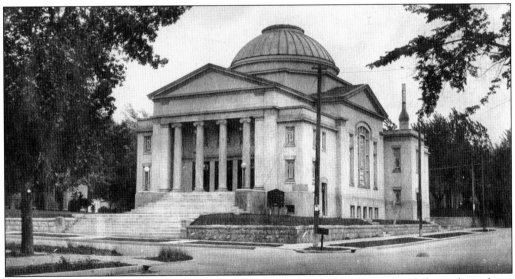

The domed First Presbyterian Church at Ridge Avenue and Elm Street was dedicated in a huge ceremony on April 11, 1920. The Greek classic style is elevated on a terrace meant to suggest the Greek hills. The four columns of Boise sandstone were transported over 300 miles of unpaved roads. (Courtesy BCHS/MOI.)

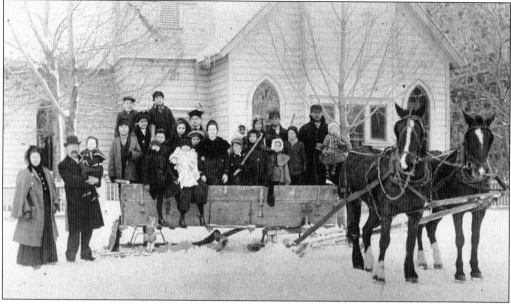

A horse-drawn sleigh, preparing to take children on a winter excursion, sits in front of the town's first Presbyterian church on Shoup Avenue. (Courtesy BCHS/MOI.)

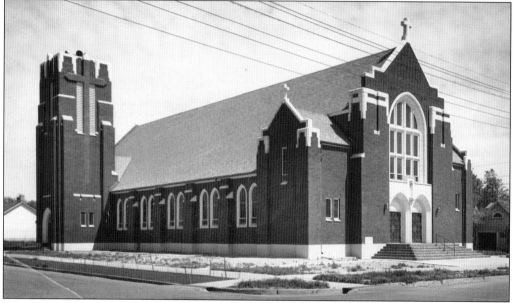

The present Holy Rosary Catholic Church was dedicated in 1949. It was Fr. Pierre Jean DeSmet, a young priest sent to teach the Native Americans, who led Idaho's first Catholic Mass in 1840 at what is now Henry's Lake State Park. The first Catholic settlers arrived at Eagle Rock in 1879, and in 1884, two city lots were obtained for a church. A small structure was completed but not furnished in 1897 on Eastern Avenue. First High Mass was celebrated in Idaho Falls on Easter Sunday in 1901 and dedicated later that year as Holy Rosary Parish. A larger church was built at Ninth and Lee Streets, and a parish school opened in 1921. Growth dictated a second parish and church, Christ the King, which was dedicated at Seventeenth and Woodruff in 1967. (Courtesy BCHS/MOI.)

Perhaps the most prominent religious building in Idaho Falls is the LDS temple overlooking the falls that gives the city its name. Present in Eagle Rock from 1880 on, early LDS settlers also attended Rebecca Mitchell's Sunday school until their own meeting house could be built in 1885. Work on the 155-room LDS temple began in 1939 and was completed in 1945 to serve 90,000 members spread over 21 stakes. The September 24, 1945, *Post-Register* said of the temple dedication, "It was an occasion rare in the history of the church, for this is the eighth such temple in present use." (Courtesy PR.)

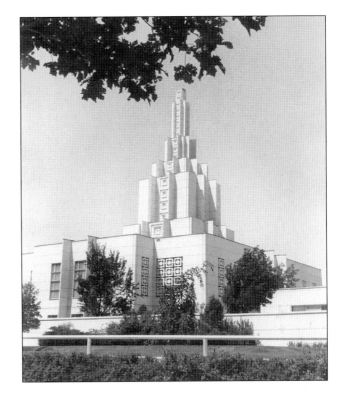

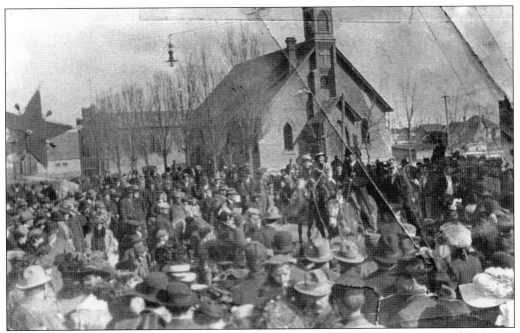

A Christmas crowd gathers outside St. John's Episcopal Church at Park Avenue and A Street. The red brick chapel was razed in 1909. (Courtesy BCHS/MOI.)

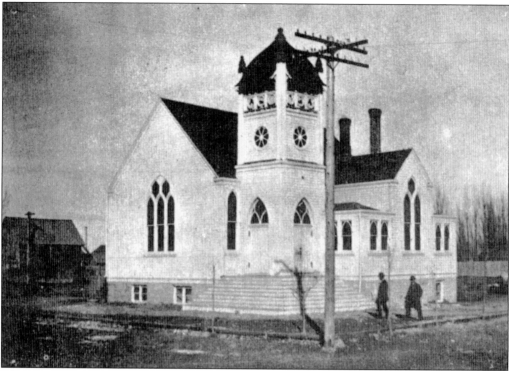

This frame building served about 30 members as the original Trinity Methodist Church at Elm and Water Streets around the turn of the century before being torn down to make way for the present church in the same location (below), built in 1917 with stone quarried from the Ririe area. The Trinity Methodist organization dates back to April 27, 1886. Its first pastor was Rev. J. P. Morris. (Courtesy BCHS/MOI.)

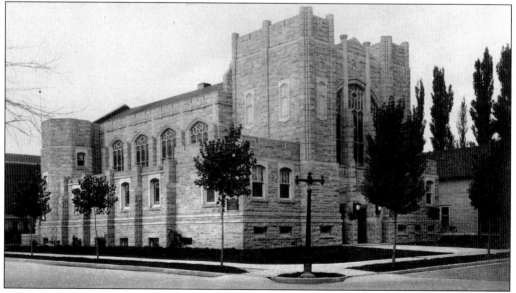

The stone Trinity Methodist Church is a local landmark and still stands today. A Methodist radio ministry was added in the 1940s. (Courtesy BCHS/MOI.)

Seven

CIVIC SERVICE
AND PHILANTHROPY

Like any municipality, Idaho Falls and Eagle Rock has had its share of diverse civic groups. Two groups, the International Order of Odd Fellows and the Eagle Rock Lodge No. 19 of the Ancient Free and Accepted Masons, began in 1886 and included many influential early townsmen. D. L. Chamberlain served as the Masons' Worshipful Master in 1890. The group began with seven members in a rented room over a butcher shop.

Early civic groups included the Order of Eastern Star, a spiritual but nonreligious fraternal organization open to both men and women that was chartered locally on April 12, 1902. A year and a half later, the Fraternal Order of Eagles opened its first lodge locally on November 21, 1903. In February 1908, the Idaho Falls Elks Lodge was established with an initiation ceremony that required charter members to wear Japanese kimonos and carry parasols in a gala parade through town, according to historian Mary Jane Fritzen.

In 1909, the Grand Army of the Republic formed here, but due to the fact that the group was for Civil War veterans, its life expectancy was short, and it disbanded in 1925. Another short-lived group was the Idaho Falls Order of the Moose, which hit its peak at 100 members but only lasted from 1910 to 1934.

Another group that is still a fixture in Idaho Falls is the local Kiwanis Club. They perform various community service projects with an emphasis on children and youth. Idaho Falls is also home to two Rotary clubs—the downtown Rotary and Idaho Falls East. The city's two groups work year-round toward civic goals, including improving the greenbelt and organizing the annual Greenbelt Duck Race. The downtown club traces its origin back to February 4, 1918, the 380th of the 33,000 Rotary clubs worldwide.

The Greater Idaho Falls Chamber of Commerce solicits individuals and businesses to join together and volunteer to advance the "commercial, financial, industrial, civic, and social interests" of the region. It also puts on the annual Taste of Idaho celebration and Fourth of July activities.

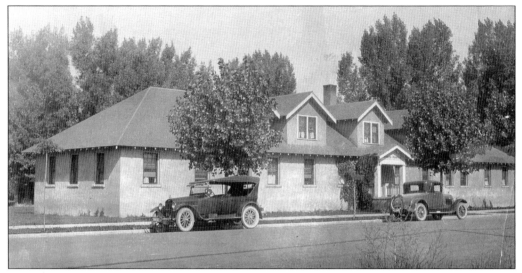

In 1870, Eagle Rock's nearest doctor was in Malad City, a four-day journey by horse and buggy. During an 1876–1877 smallpox epidemic, vaccines were rushed from Fort Hall and Salt Lake City. But by the early 1900s, two doctors lived in Idaho Falls. Spencer Hospital at Placer and Walnut was named after Dr. H. D. Spencer, who purchased it in 1916 and started the Spencer Hospital School of Nursing. It moved to South Boulevard around 1921 and was taken over in 1941 by the Franciscan Sisters of Perpetual Adoration, a Catholic order. It was renamed Sacred Heart Hospital, moving to a new building near Tautphaus Park in 1949. (Courtesy BCHS/MOI.)

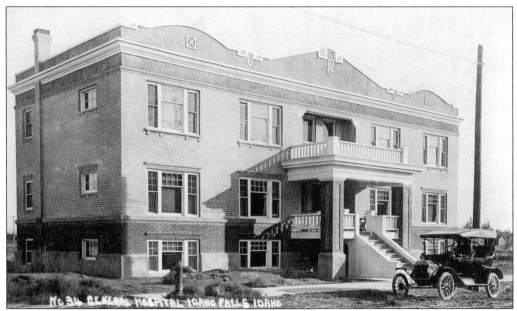

General Hospital was the first building designed and constructed as a hospital in 1915, with a 25-bed capacity. An earlier hospital of the same name was started in a private home. It was on the corner of Idaho Avenue and K Street and was maintained until 1923 when the LDS Hospital was completed. The E Street People's Hospital, built in 1916, also closed in 1923. (Courtesy BCHS/MOI.)

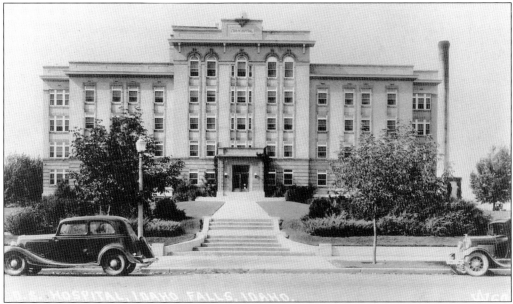

LDS Hospital was opened by the Church of Jesus Christ of Latter-day Saints on Memorial Drive in 1923 and remodeled several times before being demolished when Eastern Idaho Regional Medical Center opened in 1986. The church turned over the hospital's assets to Intermountain Health Care in the 1970s. (Courtesy BCHS/MOI.)

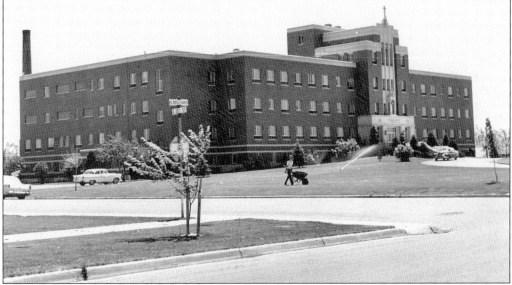

Sacred Heart Hospital merged with the former LDS Hospital to become two branches of Idaho Falls Consolidated Hospitals in 1977. Both were demolished when Eastern Idaho Regional Medical Center opened. The Community Hospital Corporation, now called the CHC Foundation, was established in 1985 to administer the money gained liquidating Parkview Hospital. In 2002, the foundation's assets totaled more than $12 million, making it the eighth-largest charitable foundation in the state. The foundation uses interest from the trust to award grants totaling more than $1 million every year. Projects meeting a charitable, scientific, literary, or educational need in eastern Idaho are eligible. (Courtesy PR.)

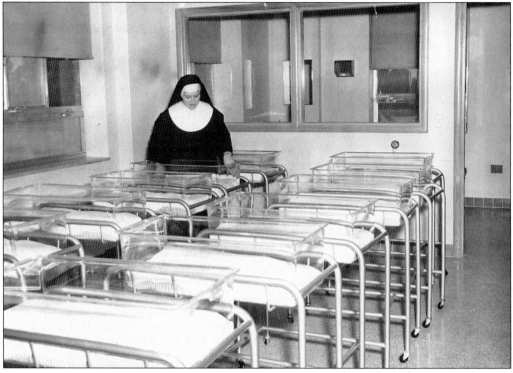

An order of Catholic nuns took over the 20-year-old Spencer hospital on South Boulevard and renamed it the Sacred Heart Hospital. In 1949, the sisters moved to a new building near Tautphaus Park, pictured here. In 1969, they gave control to a community board, which christened it Community Hospital of Idaho Falls in 1974. (Courtesy PR.)

This 1950s-era photograph was probably staged to headline an antismoking campaign at Parkview Hospital. (Courtesy PR.)

Eastern Idaho Regional Medical Center, operated by Hospital Corporation of America, became the region's primary medical center when it opened in 1986. It has five clinic locations in Idaho Falls, and the 192 physicians on staff served an average of 545 patients per day in 2004. In November 2002, a group of local doctors opened the 20-bed Mountain View Hospital down the street from EIRMC. (Courtesy PR.)

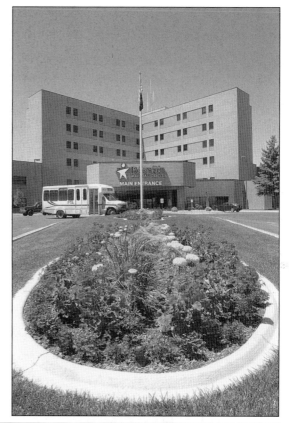

The first Odd Fellow's home at Idaho Falls is seen in this 1897 photograph. The local IOOF chapter formed a year earlier, the same year as the Masons, and its first meetings were held in the Clark and Fanning Company Building. (Courtesy BCHS/MOI.)

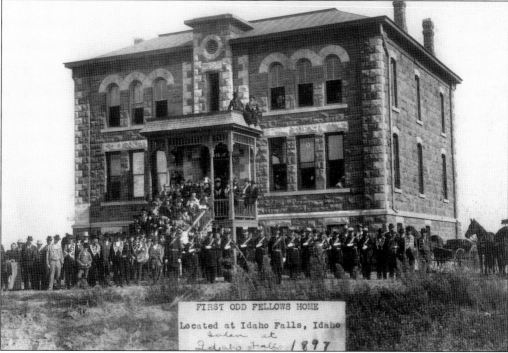

FIRST ODD FELLOWS HOME
Located at Idaho Falls, Idaho
Taken at
Idaho Falls 1897

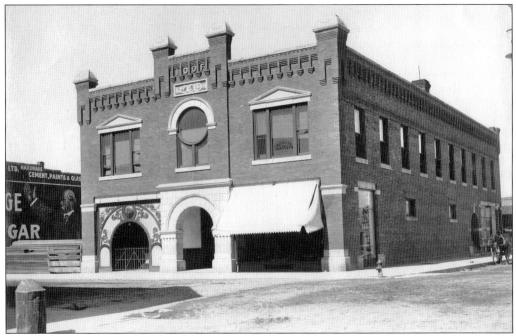

The second Odd Fellows Lodge at Park Avenue and A Street housed a dentist's office upstairs in 1909. (Courtesy BCHS/MOI.)

The Buzzard Club, a local gentlemen's club, gathers for its first Christmas reunion on December 24, 1933. (Courtesy BCHS/MOI.)

The tile floor at the Bonneville County Courthouse, built before World War II, used a swastika design until residents demanded it be altered to a more politically acceptable and less provocative symbol. (Courtesy BCHS/MOI.)

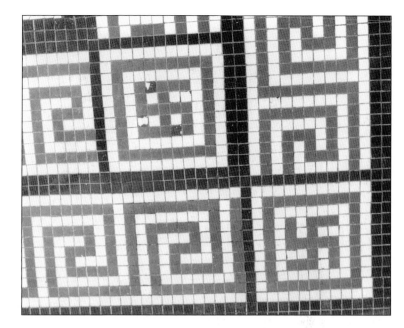

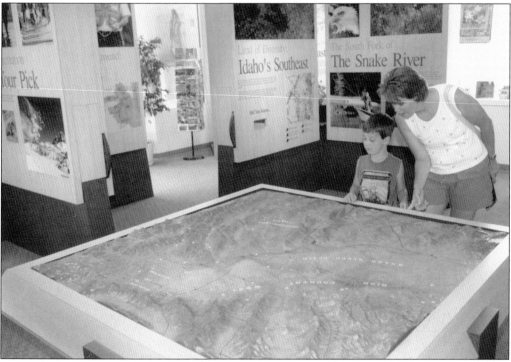

The Greater Idaho Falls Chamber of Commerce Information Center is located at 630 West Broadway Avenue, just west of the Broadway Bridge. The chamber in Idaho Falls dates back to 1907. Founded as the Club of Commerce, it became the Bonneville County Commercial Club in 1919 before it became the chamber of commerce in 1922. Its greatest accomplishment is probably the role it played in bringing the Atomic Energy Commission's headquarters to Idaho Falls in 1949. Chamber officials made several trips to Washington, D.C., to lobby for the site. (Courtesy PR.)

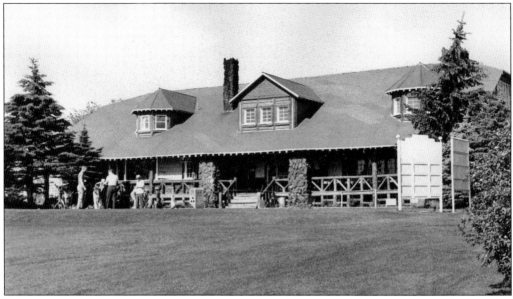

Pinecrest Golf Course is the oldest of three municipal courses in Idaho Falls. It was built in the 1930s as a Works Progress Administration (WPA) project. (Courtesy PR.)

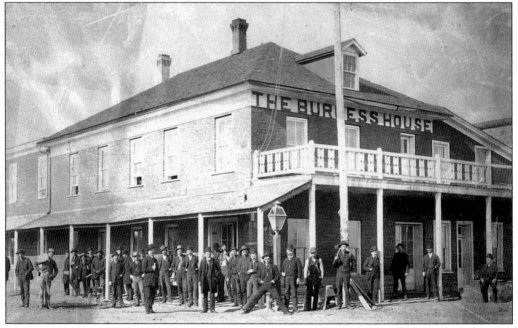

Like every other 19th-century western community, Eagle Rock had eating and rooming houses, but it wasn't until 1886 that the first actual hotel opened, the Burgess House, a two-story adobe structure at Eagle Rock Street and South Capital Avenue. After Eagle Rock became Idaho Falls in 1891, a burst of hotel building in the main section of town included the Graehl Hotel, a one-story stone building on the north side of Front Street. N. D. Porter renamed the hotel after himself in 1901 and managed it until 1930. In 1907, it became the New Porter Hotel, "And it's a daisy," gushed the December 6, 1907, *Idaho Register*. "30 new rooms added to the old Part—A Fine Place," totaling 47 rooms in all, with Brussels carpets and golden oak furniture. (Courtesy PR.)

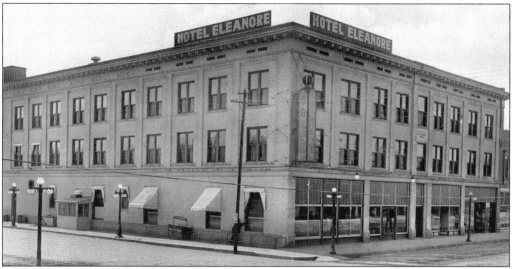

The three-story Hotel Eleanore on Yellowstone and Broadway was a favorite of passenger-train travelers. It was built in 1914. (Courtesy BCHS/MOI.)

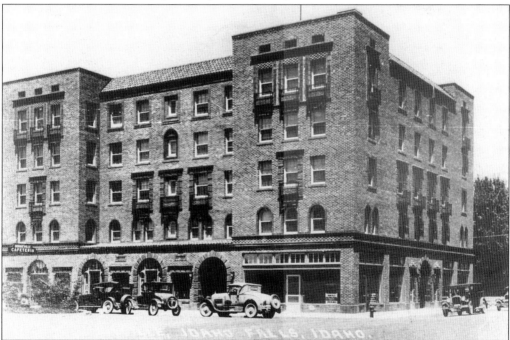

The five-story Bonneville Hotel offered public tours as Idaho Falls' first "skyscraper" at its opening in June 1927. Investors behind the 76-room hotel were a virtual who's who of the city's boosters in the 1920s. It was built as a cooperative effort of 481 citizens at a cost of $335,000—more than $3.5 million in today's dollars. With the advent of the interstate highway, which reached Idaho Falls in 1962, the lodging focus shifted to land west of the Snake River. Hotels in that part of town dated back to 1928, when Ferris Clark built two cabins by the falls. Clark expanded the Westbank's facilities to a red-brick, two-story motor lodge, adding shops. Additional rooms and an eight-story tower, still an Idaho Falls landmark, were built in the 1970s. Today, after changing owners several times, the Westbank is now the Red Lion Hotel on the Falls. (Courtesy PR.)

Telecommunications pioneer Greg Carr is largely responsible for the creation of the Museum of Idaho, which houses the Bonneville County Historical Society in the former Carnegie Library. Carr is just one of many philanthropists who have enriched Idaho Falls, beginning with Andrew Carnegie's $15,000 grant to establish the library in 1915. The Village Improvement Society—a volunteer group founded to keep the streets and alleys clean, trees and hedges trimmed, and the parks planted with flowers—prevailed upon city leaders to raise money to match the Carnegie grant. Other philanthropists include Leland D. Beckman, a Swan Valley area farmer and World War I veteran, who left a foundation that endows scholarships and contributes to the advancement of the arts in eastern Idaho. In 2001, it gave out $88,370 in grants. In 1965, Howard and Edyth Daugherty of Idaho Falls established a trust to facilitate their charitable giving. Howard Daugherty established the Westmont Tractor Company in Idaho Falls in 1934. After his death in 1983, four Daugherty Foundation funds were established through the Idaho Community Foundation. Over an eight-year period, the funds distributed $1.2 million to 65 different charities. (Courtesy PR.)

THE IDAHO REGISTER.

Kate Curley, wife of prominent banker Bowen Curley, organized the Village Improvement Society in 1898. The group cleaned up the town—literally—with an antilitter campaign and then supervised the greening of Idaho Falls by planting hundreds of hardwood trees. After her death in 1903 of cancer, Kate Curley Park was dedicated to her memory. This 1906 edition of the *Register* honored her. (Courtesy PR.)

The late Miles Willard's fund-raising, leadership and personal generosity funded a large part of the renovating of the Colonial Theater downtown. He and his widow, Virginia Willard, also set up a foundation under the Idaho Community Foundation, as did others from the area, including Roger and Sybil Ferguson, the late Joan Chesbro, and Kenlon and Carol Johnson. (Courtesy PR.)

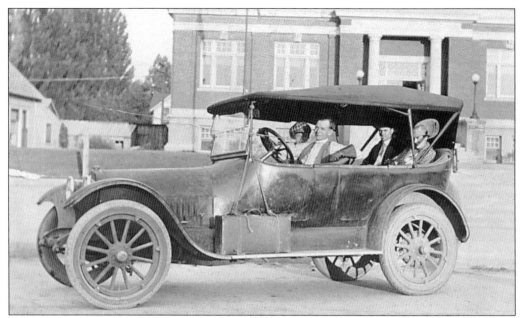

A flivver parks in front of the Carnegie Free Library. The February 10, 1905, edition of the *Register* noted, "Drs. LaRue and Bridges have purchased an automobile which they will use in going about the country to visit their patients." Although the Model T Ford wasn't introduced until 1908, and the last horse teams weren't replaced by tractors on the region's farms until the 1940s, articles began appearing about runaway horse teams being spooked by autos as early as 1906. (Courtesy PR.)

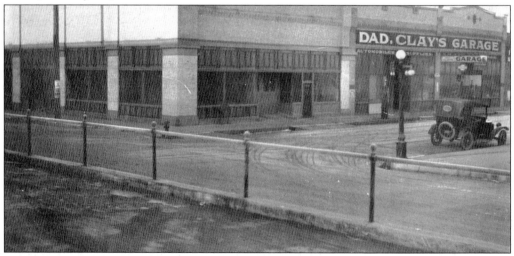

J. C. "Dad" Clay's Garage opened in 1909; this photograph was taken around 1920, when the garage also functioned as a Buick and Ford dealership. He published the first road atlas in Idaho and also constructed road signs directing motorists to his garage. The Preston A. Blair Company, founded in 1914, was Idaho Falls' first official auto dealership, selling Dodges and Plymouths. By the mid-1930s, it was estimated that nearly $1.5 million was spent annually in Idaho Falls on automobiles. As the federal highway system expanded in the 1920s and 1930s, Idaho Falls became a significant stop for travelers from Utah and California on their way to Yellowstone National Park. (Courtesy BCHS/MOI.)

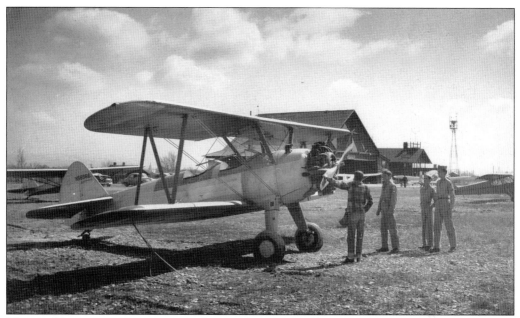

Three soldiers inspect a two-seat biplane at the Idaho Falls Airport just after the end of World War II. The first recorded air show in Idaho Falls was in 1911, when Charles Willard flew his Curtis biplane from the fairgrounds (present site of Tautphaus Park) and entertained an amazed crowd. On April 15, 1920, the first "United States aerial mail delivered in the state" was brought from Pocatello to Idaho Falls when pilot Hugh Barker and J. Robb Brady arrived in the city. In 1934, regular airmail service made Idaho Falls a stop on the route from Salt Lake City to Great Falls, Montana. (Courtesy BCHS/MOI.)

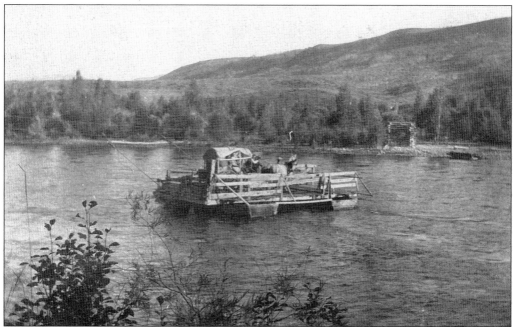

Early ferries forded the rivers of eastern Idaho, including the Snake. The ferry on the South Fork of the Snake River also took cars across to the Heise Hot Springs resort. (Courtesy BCHS/MOI.)

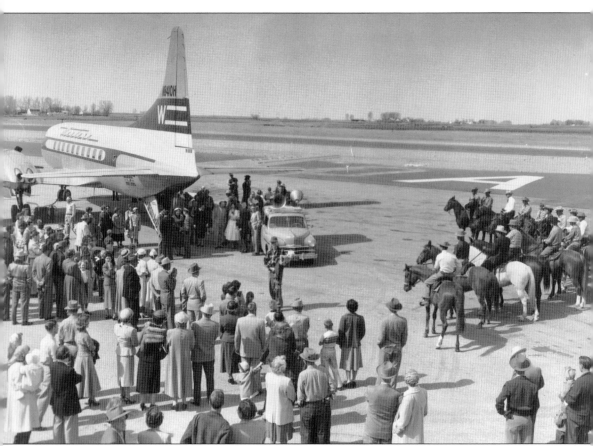

A Western Airlines Convair twin-engine commercial flight into Idaho Falls is met by a mounted sheriff's posse escorting airmail to the plane on April 20, 1953. The roots of present-day commercial service date back to the 1940s, when Western Airlines began flying into Idaho Falls. Zimmerly Airlines (later West Coast) and Hughes Airwest (later Republic) initiated westbound air service. That same decade, the first terminal building was erected at about 50 feet by 75 feet. Capitol Airways began offering flights to Boise for travelers and mail. Airport traffic increased as a string of airlines began making stops in Idaho Falls. The trend continued in 1955 with Frontier Airlines starting service to Jackson, Wyoming, and Denver, Colorado. In 1978, residents approved a $2.75 million revenue bond for airport expansion. Three years later, a 41,000-square-foot terminal opened that was four times the size of the older facility. "They got their bang for their buck," Idaho Falls Airport manager Jim Thorsen said in the April 9, 1981, edition of the *Post-Register*. The following year, Skywest and Horizon Airlines began service in Idaho Falls. Recently a regional carrier called Allegiant offered discounted nonstop flights twice a week to Las Vegas and back, and United Airlines recently began direct flights to Denver. (Courtesy BCHS/MOI.)

E. W. Fanning, the first native of Idaho Falls to be mayor, engineered the creation of Idaho Falls Airport, which was later named Fanning Field in his honor. He served from 1940 to 1949. (Courtesy BCHS/MOI.)

H. P. "Pete" Hill Jr. managed the city's airport starting in the early 1950s through a period of rapidly expanding air travel. He was the son of Wilber H. (Pete) Hill, who taught Charles A. Lindbergh how to fly. He began flying at age 16 at about the time his father was state aeronautics director. Orville Wright signed his pilot's license. (Courtesy BCHS/MOI.)

The Eastern Idaho Railroad handles freight services on leased tracks north of Idaho Falls. (Courtesy BCHS/MOI.)

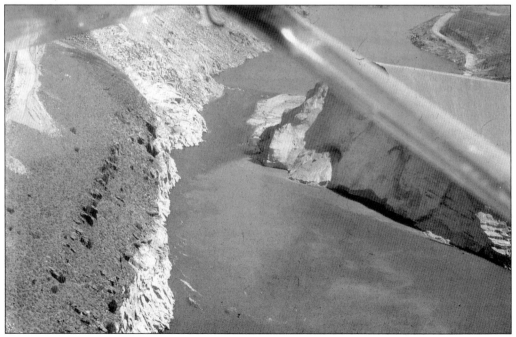

An aerial view of the massive break in the Teton Dam shows the reservoir behind it slowly emptying onto the Snake River Valley below on June 5, 1976. Volunteers, many provided by service organizations, and local units of the National Guard were essential in protecting Idaho Falls from the Teton Dam flood. (Courtesy Idaho Falls Power.)

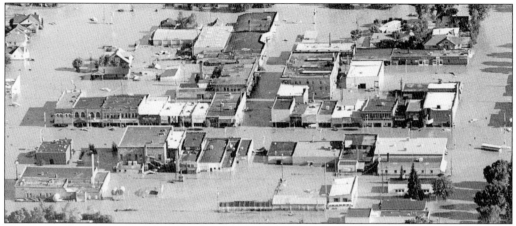

Downtown Rexburg is inundated with water from the Teton Dam failure on June 5, 1976. Idaho Falls would soon be hit as well. (Courtesy Idaho Falls Power.)

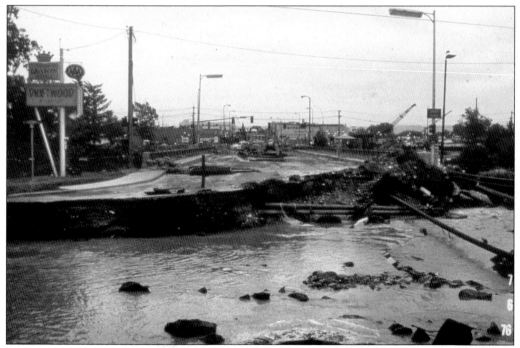

In order to relieve pressure on the underpinnings of Broadway Bridge during the 1976 Teton Dam flood, a channel was cut across it to allow water through. The new dam failed on June 5, 1976. Eleven people died in the Upper Snake River Valley, 4,000 houses were damaged or destroyed, and 350 businesses were lost. Damage estimates were pegged at $2 billion. (Courtesy Idaho Falls Power.)

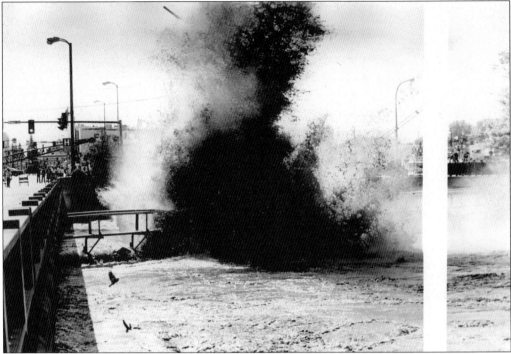

A plume of water rises above the floodwaters on the north side of Broadway Bridge in downtown Idaho Falls. Idaho Falls waited nearly two days for the flood's arrival, with volunteers sandbagging the river and making other drastic emergency preparations such as cutting a channel in the Broadway Bridge to try to save it. Hundreds of volunteers worked day and night on the preparations, and after the river crested, they moved north to help their neighbors in the Rexburg area recover from the devastating disaster. (Courtesy Idaho Falls Power.)

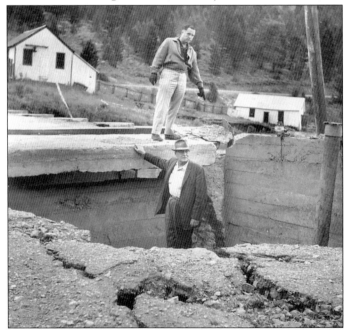

Fissures from the 1959 Yellowstone earthquake damaged bridges in eastern Idaho. (Courtesy PR.)

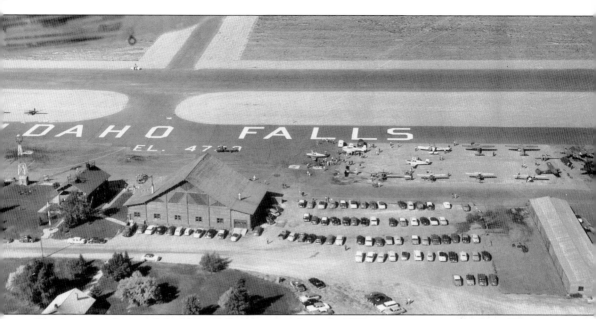

This is an aerial view of the Idaho Falls airport in the early 1950s. Runways were paved as a Works Progress Administration project starting in 1941, and regular commercial air service began in 1945. In the 1920s, the city acquired 200 acres on the west side for a 1,500-foot-long airfield. In 1929, National Park Airways carried the first passengers to Idaho Falls Municipal Airport. The next year, the U.S. Department of Commerce installed a beacon, a landing area, and boundary lights. D. F. Richards built the first aircraft hangar the same year. (Courtesy BCHS/MOI.)

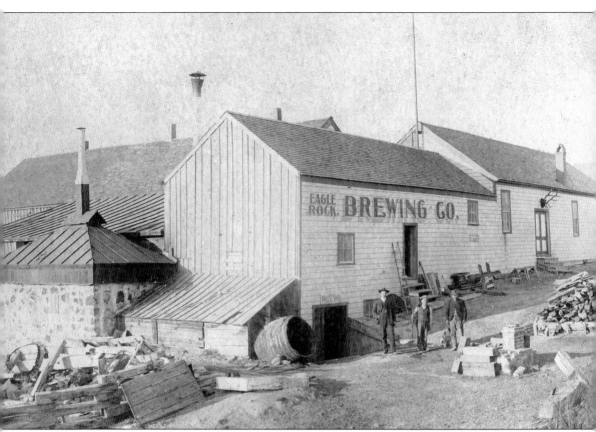

By 1887, the town of 1,500 had a brewing facility, the Eagle Rock Brewery, which exported to neighboring communities. Eagle Rock went on to have at least one brewery in operation until Prohibition and again after it until 1939, according to beer historian Gregg Smith. Notables included Bannock Brewing (1895 to 1907) and Pilsner Brewing Company (1935 to 1937). The Idaho Falls Brewing Company opened in 1905 at an initial cost of $80,000, with plans to add a bottling works and a malt house. "Every successful town has its own brewery," the *Idaho Register* opined in March 1905. "(We) defy any spot in America to produce a better brand of barley than the Snake River Valley or a more superior brand of judges to pass upon the beer after it is brewed." Beer still plays a part in the Idaho Falls economy. Now microbrewers come from across the West to take part in the annual Mountain Brewers Beer Fest at Sandy Downs, with all proceeds going to charity. Anheuser-Busch operates a malt plant, a seed facility, and a barley elevator. The malt plant opened in 1991, expanded in 2004, and employs 59 people. It contracts more than 20 million bushels of barley from Idaho farmers, generating $73 million in income for growers. In 2005, the company employed a total of 160 people in Idaho with annual salaries adding up to $7.6 million, local taxes totaling $2.5 million, and supply purchases bringing in another $31 million to the state. Grupo Modelo began producing 100,000 metric tons of malt at its plant in 2005 and employs 35 locals in addition to bringing in occasional foreign workers. The plant started buying local barley in September 2004. (Courtesy BCHS/MOI.)

Eight

AGRICULTURE
AND BUSINESS

It shouldn't be a surprise to anyone that most of the early businesses in Idaho Falls were based on agriculture. The businesses that sustain Idaho Falls today are the same that did in its early days. Idaho Falls is a crossroads, and as such it has evolved as a regional center for retail, warehousing, shipping, and real estate.

Idaho Falls is the home base for Melaleuca, a direct-marketing company with a worldwide network of sales representatives that posts annual sales of more than $500 million. It is also home to Chesbro Music, the largest wholesaler of sheet music west of the Mississippi River. Other old-time businesses that have survived a century or more include the Old Faithful Beverage Company (1902), Johnson Brothers (1905), and First American Title (1902).

It would be inexcusable to ignore the businesses in eastern Idaho that had a basis in agriculture, from Miskin Scraper Works of Ucon, which began in 1917 and continues to this day, to Rogers Brothers Seed Company, which started a pea-production program in Idaho Falls in 1911. In 1926, Rogers Brothers became the nation's first successful commercial producer of potato flour. In 1957, it became the first company to manufacture potato flakes. The company left Idaho Falls in 1986, moving to Boise.

Growing crops on the arid Snake River plains requires bringing water to them. Settlers like these in New Sweden organized irrigation companies that either charged an annual fee to farmers or a single larger sum for a permanent water right. Friction between the companies and farmers led the state legislature to pass a law permitting farmers to organize irrigation districts in 1891. The Desert Land Act of 1894, generally known as the Carey Act, was responsible in large part for crop development in arid states by allowing settlers to obtain water for up to 160 acres, which included title to the land. Each water containment and delivery system eventually would revert to a water users association. (Courtesy PR.)

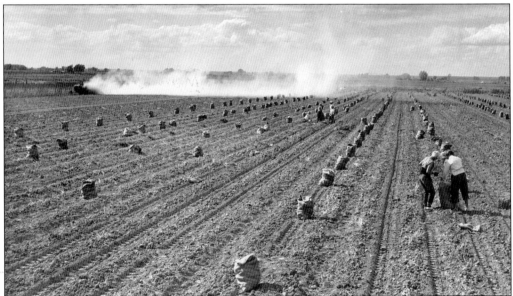

A potato harvest in New Sweden in the 1960s was still done the old-fashioned way—pickers filled buckets and sacks with spuds, which were collected on flatbed trucks and taken to market or storage. *Beautiful Bonneville*, a book written for the state's centennial, reports the New Sweden area west of the Snake River was settled in 1894–1895 when Western Land and Irrigation Company and Great Western Canal and Improvement Company advertised for Swedish settlers. The entire length of the Great Western Canal eventually was lined with Swedish farms. (Courtesy BCHS/MOI.)

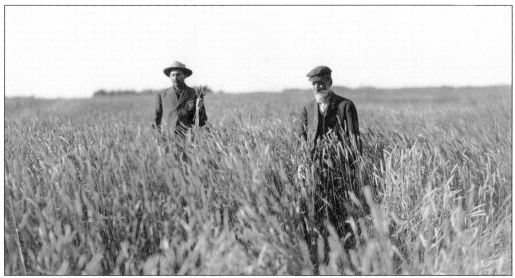
Farmers inspect a grain field to see if it is nearing harvest time. (Courtesy BCHS/MOI.)

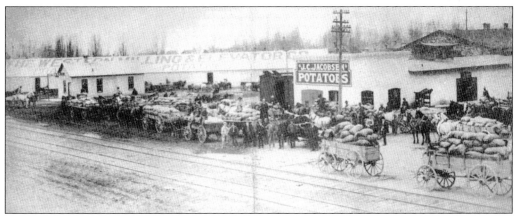
The J. C. Jacobsen potato warehouse was situated on the west bank of the Snake River in the early 1900s. Note the Consolidated Wagon and Machine Company lava-rock building in the background, which is still standing just west of Broadway Bridge. (Courtesy BCHS/MOI.)

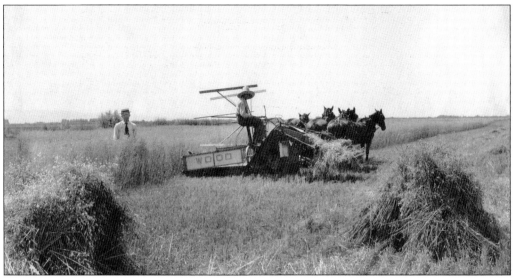

Harvesting oats using horse-drawn equipment was still common practice into the early 1940s in eastern Idaho. (Courtesy BCHS/MOI.)

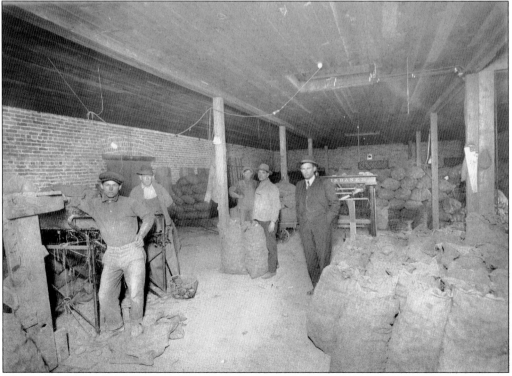

This is the Howard and Bennett Wholesale Potato Warehouse, where potatoes were inspected and sorted prior to shipping. (Courtesy BCHS/MOI.)

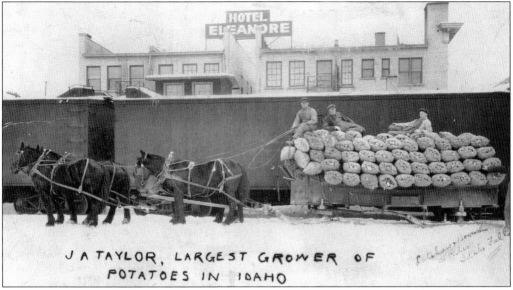

J. A. Taylor was the largest grower of potatoes in Idaho around 1910. Potatoes are sometimes stored in cellars and shipped in winter or spring when prices are (sometimes) higher. (Courtesy BCHS/MOI.)

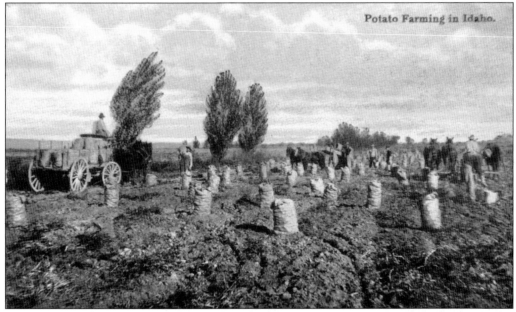

This postcard presents an idyllic scene of potato farming in Idaho in the early years of the 20th century. As the town began to grow, newspaper publisher William E. Wheeler promoted the region's agricultural possibilities, a destiny fulfilled with the help of land and water developers like James H. Brady and the town's first mayor, Joseph Clark, and by an influx of Mormon settlers who built irrigation systems up and down the valley. (Courtesy PR.)

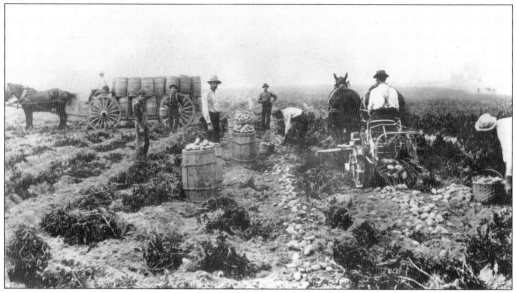

The early model of a horse-drawn potato digger and the handpicked potatoes loaded in wooden barrels indicates this photograph may have been taken before potato sacks were used, around the turn of the 19th century. (Courtesy BCHS/MOI.)

The Idaho Canal Company was intended to bring water to allow starving Native Americans on the Fort Hall Reservation to raise their own food instead of relying on inadequate government support. But the first irrigation system on the reservation turned out to be a "fraud," according to historian Brigham Madsen. Idaho Falls mayor Joseph Clark led a group of investors in 1895 to build the project, but due to government delays, by the time the project began, most of the water rights in the Blackfoot and Snake Rivers had already been appropriated. Problems in the canal's construction resulted in numerous breaks, floods, and failures, and Native Americans suffered crop losses. Finally the company was placed in the hands of a receiver and sold. (Courtesy BCHS/MOI.)

Joseph A. Clark, a civil engineer and surveyor, helped lay
out Eagle Rock after he arrived in 1885, served as the
town's first mayor from 1900 to 1902, and was the
driving force behind the city's water and power
systems. His sons, Barzilla and Chase, both served
as Idaho Falls mayors and as Idaho governors.
(Courtesy PR.)

James H. Brady, one of the stockholders in
the Idaho Canal Company, purchased the
project in 1900 for $75,000. He continued to
operate it as a private concern until selling it
back to the government in 1908, around the
time he became governor, for $90,000. Local
stockholders, including Charles Tautphaus,
took a soaking from their participation. Most
eventually realized a return of about 25¢ on
the dollar. But the Native Americans fared
far worse. Forced onto the reservation by
the enmity of encroaching whites and given
inadequate food and supplies for existence,
Shoshonis, Lemhis, and Bannocks suffered
decades of deprivation. Whites routinely stole
their water and encroached on their lands.
Native Americans were given little in the way
of equipment to farm, and some of the money
they were paid for acreage taken was used to
pay for improvements in the privately owned
irrigation system. By the time the project was
returned to government ownership, Native
Americans declined to rely on the system for
basic water supplies. (Courtesy PR.)

107

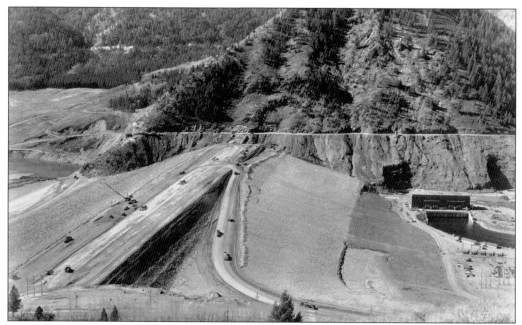

Palisades Reservoir was a Reclamation Service project authorized in 1941 but was delayed by World War II and not completed until 1957. Congress, in 1902, passed the Reclamation Act that provided federal funds to build irrigation systems in arid states and created the Reclamation Service, the forerunner of the present Bureau of Reclamation. The first such work in Idaho was the Minidoka Reclamation Project, authorized in 1904. Other Bureau of Reclamation structures completed in eastern Idaho include Jackson Lake Dam, completed in 1911; Island Park Dam, completed in 1938; and Grassy Lake Dam, northwest of Moran, Wyoming, completed in 1939. (Courtesy BCHS/MOI.)

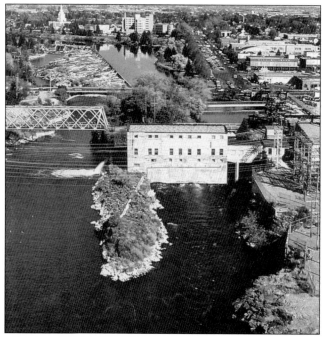

The city built and updated several hydropower plants over the years on the Snake River, beginning in 1906. Idaho Falls has had its own utility since 1900, supplying most of the city's power needs until 1943. But the aging power plants on the Snake River were deteriorating when the Teton Dam flood hit in 1976, heavily damaging them. Upper, lower, and city plants were demolished in 1978, and bulb turbines were installed. (Courtesy of Idaho Falls Power.)

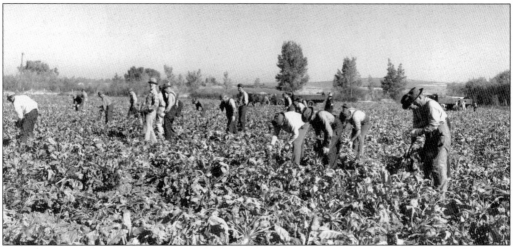

Sugar beets are a good crop for eastern Idaho but require labor-intensive topping and weeding, as in this picture taken during World War II. While beets are still grown along the southern stretch of the Snake River between American Falls and Burley, the 1978 closure of the Utah-Idaho Sugar Company's Idaho Falls processing plant marked the industry's evacuation of this part of the valley. That plant was the last vestige of an industry that sprouted when the Utah Sugar Company, organized by the LDS Church to bring another cash industry to the area, built the facility in Lincoln, just east of Idaho Falls in 1903. Other processing plants opened in Shelley, Rigby, and Blackfoot. A plant north of Rexburg spawned the town of Sugar City. But changing times led to shuttered windows. The Idaho Falls plant was the only one in eastern Idaho to survive past 1950. (Courtesy BCHS/MOI.)

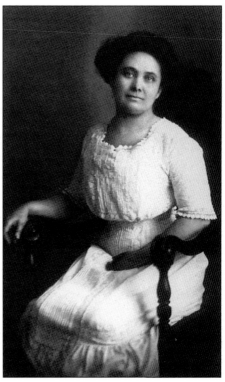

Minnie G. Hitt was a longtime pioneer banker and investment counselor. She started as a clerk at the Anderson Brothers trading post after arriving in 1889 with her widowed mother and sister at age 17. She was a fixture in the local banking scene for half a century. (Courtesy BCHS/MOI.)

Old Faithful Beverage Company began in this lava-rock and brick building in 1902 and is still in business today as part of the Admiral Beverage Corporation. (Courtesy BCHS/MOI.)

This shows the interior of Farr Candy Company in 1915. The company started in 1911 and makes and markets several well-known treats, including Cherry Cordial, Mallo-Nut, Peanut Clusters, and Black Walnut Bar. The company also markets gift boxes of the famous Idaho Spud Bar, a marshmallow fondant center dipped in chocolate, rolled in coconut, and wrapped to resemble an Idaho potato. The Spud Bar is made in Boise. (Courtesy BCHS/MOI.)

Arthur R. Miskin founded Miskin Scraper Works in 1917 when scrapers were pulled by horses. The company, a leading manufacturer of scrapers and dirt-moving equipment, ships products worldwide. (Courtesy PR.)

The Idaho Livestock Auction, one of the city's oldest businesses, still lends a flavor of the Old West to the city's downtown. The first livestock auction was held at Idaho Falls in 1936 and continues to be held weekly. (Courtesy PR.)

Carl Johnson, center, his wife, seven sons, and daughter founded the family business, Johnson Brothers, in 1905. A century later, it's still in family hands, operating in the original location. (Courtesy PR.)

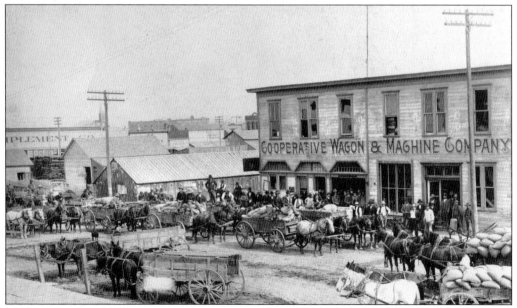

Wagons line up to trade outside Cooperative Wagon and Machine Company. (Courtesy BCHS/MOI.)

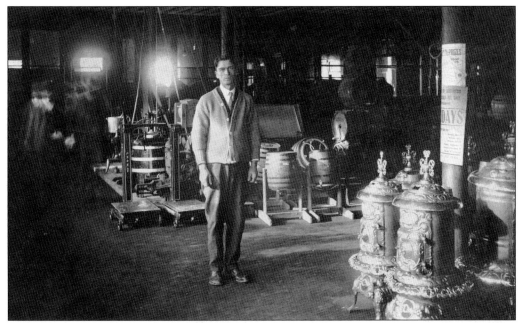

Potbellied stoves and farm implements were among the items sold by Albert Greenwell at the Consolidated Wagon and Machine Company, which came to Eagle Rock in 1889. With branches all over Idaho and Utah, the company sold farm machinery, buggies, seed, farm supplies, saddles, and clothing. The company's mainstay in Idaho Falls was Gilbert George Wright. (Courtesy BCHS/MOI.)

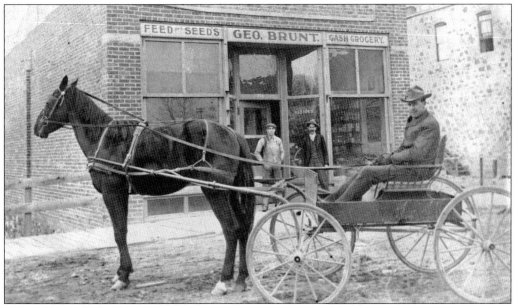

This is George Brunt outside his store at 357 A Street around 1904. Fires in 1885, 1903, and 1904 burned several downtown businesses at a time when most were made of wooden frame. Masonic lodge records detail how Brunt was visited by a salesman and signed a fire insurance policy on his small grocery store an hour before the fire broke out, depositing $1 down on a $500 policy. The policy was honored, and Briggs and McCutcheon paid the loss. (Courtesy BCHS/MOI.)

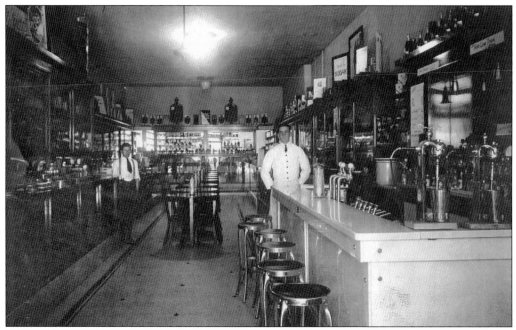

Pictured here is the Joy Drug Store and its soda fountain. The counter-service fountain became popular in the 1900s and typically sold candy and cigars as well as sodas and notions. Aside from younger patrons, it was an answer to the saloon for nondrinkers during an era leading into Prohibition. (Courtesy BCHS/MOI.)

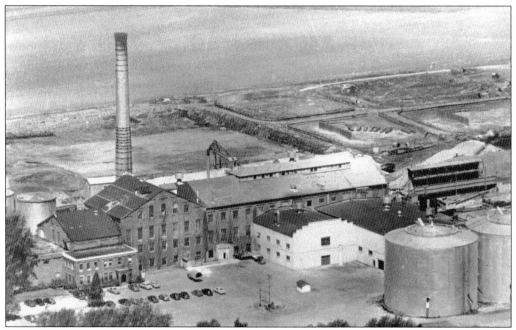

The Utah and Idaho Sugar Factory at Lincoln is pictured near the end of its heyday. The national Sugar Bounty Bill was passed in 1903, ensuring that "a large sugar factory will be built . . . it will be one of the largest in the United States." The factory closed in 1978. (Courtesy BCHS/MOI.)

Nine

IDAHO FALLS
AND THE MILITARY

Even before the town of Eagle Rock had its railroad shops or even a newspaper, it had the National Guard. On April 18, 1881, news came that Gov. John Neil had granted permission to organize a company of the National Guard and 34 men were sworn in, led by D. F. "Captain Dick" Chamberlain. Since then, the region's Army National Guard units in the Upper Snake River Valley have served in most major U.S. wars.

Present-day National Guard units in eastern Idaho began as volunteer militia groups during trouble with Native Americans in the 1870s, and soldiers from eastern Idaho served in the Philippines during the Spanish-American War. During World War I, guard members fought for the United States in France. In World War II, young men in eastern Idaho and across the nation joined the military. The Idaho Guard soldiers served in the Pacific theater.

A total of 305 eastern Idaho servicemen from all branches of the military died in World War II. Bonneville County lost the most with 110 servicemen killed in the war. Eight other eastern Idaho counties lost the remaining men. "Not a county was spared," the *Post-Register* wrote in an August 14, 1945, article. "All sacrificed men in the world conflict just ended."

During the Korean War, Idaho National Guard troops were deployed. Soldiers from eastern Idaho came home after a year of duty. In 1969, eastern Idaho Guardsmen returned from serving in Vietnam. Gov. Don W. Samuelson welcomed the soldiers back in a ceremony at Idaho Falls High School.

During the Persian Gulf conflict in 1991, no eastern Idaho Guard units were called up. But that changed when U.S. troops went to Iraq in 2003, and 24 soldiers in the Driggs-based 938th Engineer Detachment served in Iraq as airfield firefighters. Within months of their return in 2004, troops in the 116th Cavalry Brigade departed for Iraq. About 500 eastern Idaho soldiers are now serving in the Middle East.

The Bonneville County chapter of the American Red Cross was started in 1913 and filled a vital role in local civilian war efforts, organizing during World War I to produce a variety of items needed by America's so-called expeditionary forces: sweaters, socks, and scarves, but also surgical dressings, fracture pads, operating gowns, and "comfort bags" for troops. World War II moved closer to home, with an army airbase at Pocatello. Local Red Cross workers added such items as pneumonia jackets and slippers to the list of items produced for soldiers, along with raising thousands of dollars in donations to aid the war effort. Eastern Idaho farmers and ranchers also played their part, increasing production of produce and dairy items to meet the war's demand.

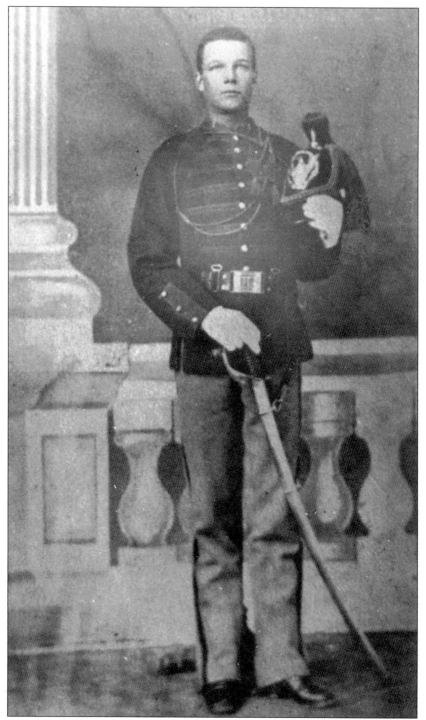

Eastern Idaho's first war casualty, Bugler Bernard Brooks, was killed in an engagement with the fleeing Nez Perce Indians on August 20, 1877, while serving with Gen. O. O. Howard's First Cavalry, Company B. He is buried near the battleground at Camas Meadows near Kilgore, just south of the Continental Divide and about 60 miles from Idaho Falls. (Courtesy PR.)

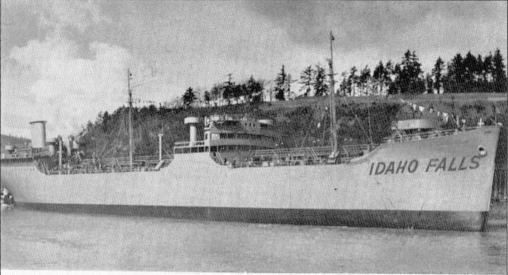

THE TANKER IDAHO FALLS, LAUNCHED MARCH 25, 1944

The SS *Idaho Falls* was one of hundreds of T2 tankers built in Portland, Oregon, in 1944 to fuel America's far-flung war effort and to replace tankers sunk by German U-boats in the North Atlantic during World War II. The 16,000-ton tanker was one of hundreds churned out from the Swan Island Yard, which is still operating. It was sold to Standard Oil Company in 1957 and renamed the *Idaho Standard*. Though arguably the American nuclear navy was born among the arid sagebrush flats of the Lost River Desert, no United States warship has ever been named for an eastern Idaho town. (Courtesy BCHS/MOI.)

David Bleak, an army medical sergeant from Idaho Falls was added to the region's list of Medal of Honor winners during the Korean War. He joined the U.S. Marines at Shelley and was trained as a medical corpsman. He volunteered to accompany a reconnaissance patrol assigned to capture a prisoner near Minari-gol, Korea, on June 14, 1952. Bleak's patrol came under fire from a trench on the ridge. Bleak tried to attend to wounded comrades while under attack. "Entering the trench he closed with the enemy, killed two with his bare hands and a third with his trench knife," the medal citation states. "Moving from the emplacement, he saw a concussion grenade fall in front of a companion . . . and shielded the man from the impact." He was injured but "undertook to evacuate a wounded comrade. As he moved down the hill . . . he was attacked by two enemy soldiers with fixed bayonets. . . . He grabbed them and smacked their heads together, then carried his helpless comrade down the hill to safety." He died in spring 2006. (Courtesy PR.)

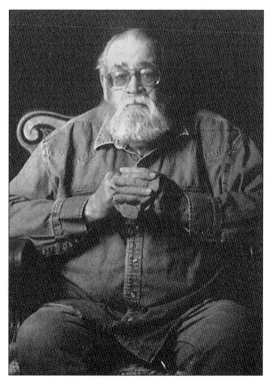

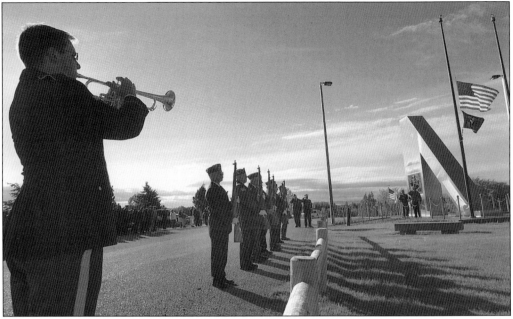

An honor guard plays taps at the Vietnam War Memorial in Freeman Park in Idaho Falls, the state's only memorial honoring Vietnam War participants. (Courtesy PR.)

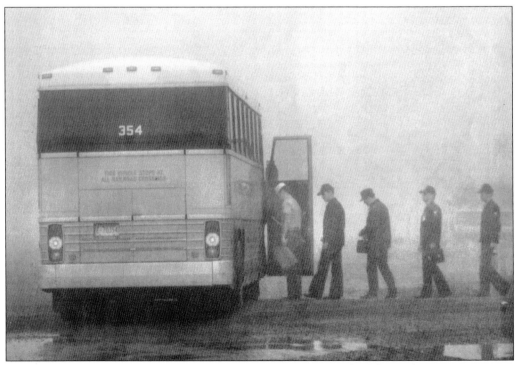

A line of navy personnel board a site bus on a foggy morning. Much of the nuclear navy's training was conducted at the Idaho National Engineering Laboratory from the 1960s through the 1990s. (Courtesy PR.)

Ten

SCIENCE IN THE DESERT

After World War II, when the United States demonstrated the impacts of an atom's destructive power, it established the Atomic Energy Commission (AEC) to begin to find peaceful uses for the atom. Researchers successfully created a nuclear chain reaction in Chicago in 1942 and decided they needed a more remote site to use for a reactor testing station.

Idaho Falls strongly courted the AEC, and on May 18, 1949, the *Post-Register*'s banner headline declared selection as headquarters for the National Reactor Testing Station (NRTS). Construction of the Experimental Breeder Reactor-1 began soon after.

On December 20, 1951, the electricity the reactor generated was used to power four lightbulbs; the first time in history nuclear energy had generated usable electricity. Another 51 test reactors have been built at the site since then, although some were canceled before ever being powered. They included some unusual ideas, including a reactor intended to power an airplane that could fly without refueling.

The navy had a strong presence at the site, one that still remains. It tested the prototype for the first nuclear-powered submarine at the NRTS in 1953, training sailors in nuclear operations at its Naval Reactors Facility located within the site boundaries.

During the cold war, the army funded research into small reactors that would be either stationary, which powered remote army radar stations, or portable, which provided a power source in the field. Its Stationary Low-Power Reactor No. 1 (SL-1) was the first to be built and made history on January 3, 1961, when it became the only reactor at the site to be accidentally destroyed, killing all three of its operators. The accident caused the fledgling nuclear power industry to rethink many of its assumptions about the "inherent" safety of reactor design and operator training and resulted in a number of improvements.

Meanwhile, another project at the site was busily consuming large supplies of mercury to try to shield a nuclear engine for an airplane that might never have to land. The air force wanted it to fly around Russia and keep an eye on its enemies. But designers figured the plane would have to weigh at least 60,000 pounds and be 205 feet long, and thus the runway would have to be over four miles long. And what if it crashed? President Kennedy scrapped the project in 1961.

The NRTS was renamed the Idaho National Engineering Laboratory in August 1974. In February 2005, it became the Idaho National Laboratory with a renewed focus on nuclear power. It is currently designing a new prototype "Generation IV" reactor that would generate electricity and steam.

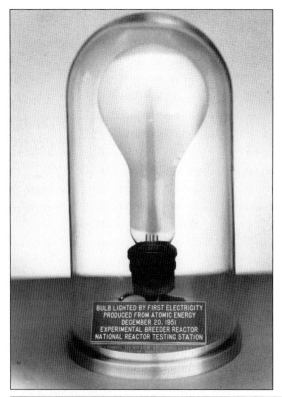

This lightbulb was the first to glow by atomic energy on December 20, 1951, at the Experimental Breeder Reactor (EBR-1) outside of Idaho Falls at the NRTS, now the Idaho National Laboratory. (Courtesy BCHS/MOI.)

The chalkboard reads, "Electricity was first generated here from Atomic Energy on Dec. 20, 1951." The next day, "All of the electrical power in this building was supplied from Atomic Energy." The nearby town of Arco became the first city in the world to be powered by a nuclear reactor, which was the EBR-1. (Courtesy Argonne National Laboratory, ANL 201-270.)

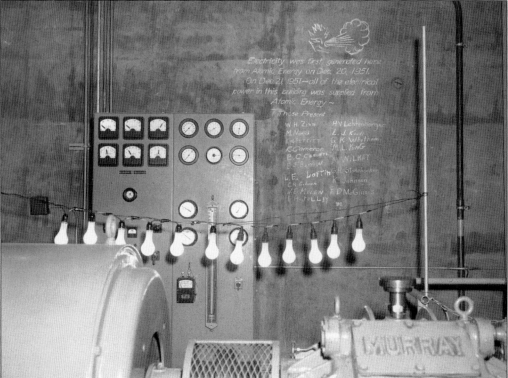

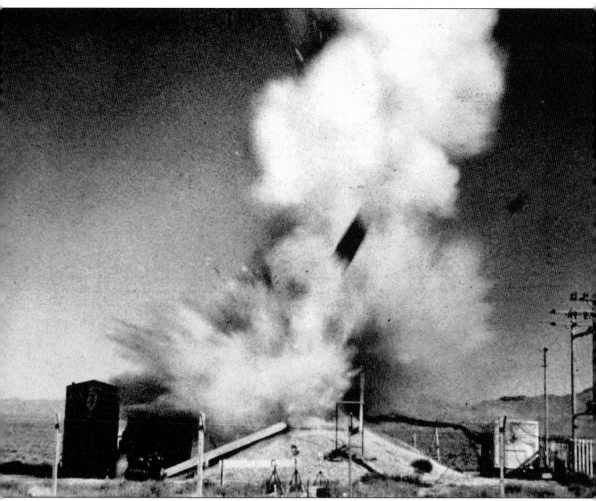

This is an "excursion" at BORAX-1, where the principles of "inherently safe" boiling-water nuclear reactors were tested and proved. The first controlled explosion took place in July 1954, a few hundred yards off U.S. Highway 26 near the EBR-1 facility. During initial tests, tourists passing by on the highway reported seeing a geyser like Old Faithful in the middle of the Arco desert. (Courtesy Argonne National Laboratory, West 201-709.)

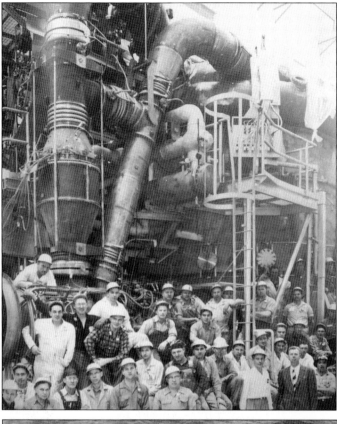

An aircraft nuclear-propulsion crew poses in front of a prototype reactor at the NRTS that was designed to test the principle of powering an airplane with a reactor. A hangar was built for the proposed plane in 1959, but President Kennedy killed the program in 1961, saying the "possibility of a militarily useful aircraft in the foreseeable future is still very remote." Designers figured a nuclear-powered airplane would weigh at least 600,000 pounds. Plans for the runway showed a strip 23,000 feet long—over four miles. (Courtesy PR.)

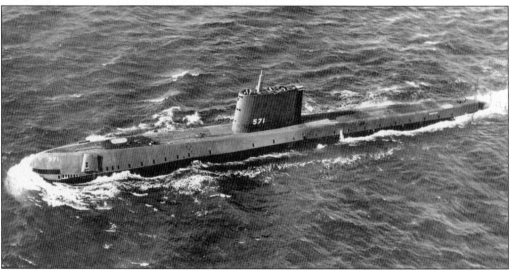

The first atomic engine to propel a ship powered the USS *Nautilus*, pictured here at sea. The *Nautilus* power plant was actually the second full-size power-producing atomic engine in the nation's history. The first, S1W at the National Reactor Test Site near Idaho Falls, was a land-based prototype later used as a training reactor for nuclear submarine crews. The *Nautilus* engine (S2W) was the first ever to provide motive power for any vehicle or vessel by controlled nuclear fission. (Courtesy PR.)

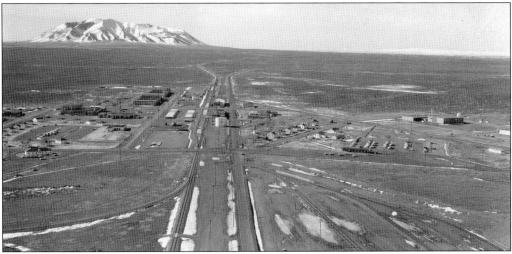

This is an aerial view of the central facility at the National Reactor Testing Station. With a workforce that topped out in 1993 at nearly 13,000, the Idaho National Laboratory's impact on business has been one of the reasons Idaho Falls has grown into a regional trading and service center. (Courtesy BCHS/MOI.)

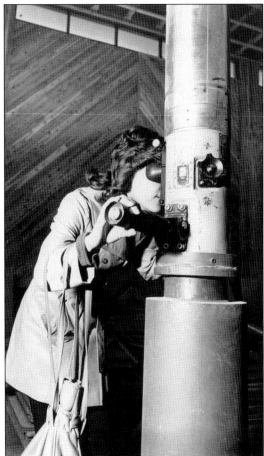

A visitor looks through the submarine telescope that was built into the Intermountain Science Experience Center, a bicentennial project near Freeman Park intended to be a showplace for the region's science-based industries and an educational center. On 26 acres, the facility was built for $2.8 million but had funding troubles and was sold to the University of Idaho in 1980. It became the centerpiece for the University Place campus, where three Idaho universities offer continuing education and distance learning from a satellite campus. The periscope was later removed. (Courtesy PR.)

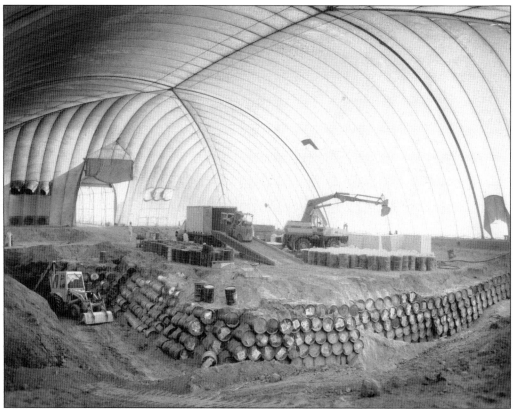

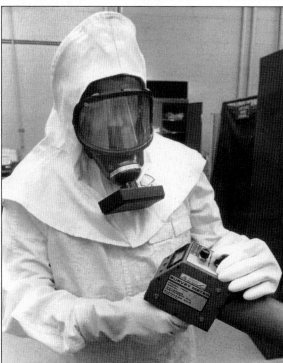

In the 1970s, Idaho became a nuclear waste repository. Here barrel retrieval takes place in pits 11 and 12 inside an air-supported building in 1977. The building contained airborne contamination and was inflated after being moved to a new work location, where barrels of buried nuclear waste were dug up and moved. (Courtesy BCHS/MOI.)

Eastern Idaho Technical College (EITC) student James Brush of Kellogg works with a meter that registers radioactive particles as part of EITC's Radiation Safety Technology program in this 1983 photograph. The state-supported technical college in Idaho Falls was created in 1969 as a minimal-cost, open-door institution that champions technical programs. The college's technical curriculum has benefited from proximity to the Idaho National Laboratory. (Courtesy PR.)

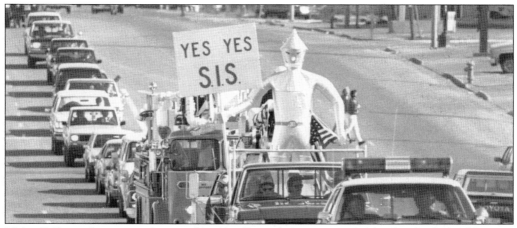

Idaho Falls residents staged a parade and rally to demonstrate support for the Special Isotope Separator (SIS) project in the mid-1980s. Most of those in the parade were construction contractors or workers, along with mayors, merchants, and the chambers of commerce in the area. There was also growing moral opposition in the area against the project, designed to make plutonium for nuclear weapons. SIS was the second Department of Energy defense project earmarked for Idaho following President Reagan's 1983 Strategic Defense Initiative, but both SIS and the New Production Reactor were canceled as the cold war wound down. Meanwhile, another defense project, the secret "Project X," did materialize. A three-story manufacturing facility was built inside a surplus warehouse in a remote location to guard it against satellite detection. It began in the fall of 1983 and started manufacturing radiation-hardened tank armor for the M1-A2 Abrams tank in 1988. Later it was designated Specific Manufacturing Capability. The tank armor was battle-proven in the Persian Gulf War. (Courtesy PR.)

A badly damaged stainless-steel fuel rod assembly top from the Three Mile Island (TMI) reactor is shown in a hot cell at the Idaho National Engineering Laboratory. INEL scientists were able to quickly simulate the accident and reassure the nation that hydrogen inside the containment vessel was unlikely to explode. A support team from INEL flew to Harrisburg, Pennsylvania, and helped secure the plant in a "cold shutdown position" before beginning months of investigation to find specific causes using the site's Power Burst Facility to develop new training and emergency-response techniques for the commercial nuclear power industry. Finally, TMI accident debris found its way to eastern Idaho for safe temporary storage. The last shipment arrived in Idaho in 1990, and the first shipment of high-level TMI waste left the state for permanent storage in March 1999. (Courtesy PR.)

BIBLIOGRAPHY

Bagley, Jerry. *The First Known Man in Yellowstone.* Rigby, ID: Old Faithful Eye-Witness Publishing, 2000.

Carter, Kate B., assisted by Clara B. Steele. *Pioneer Irrigation, Upper Snake River Valley.* Daughters of Utah Pioneers, 1955.

Davis, James W. *Aristocrat in Burlap, A History of the Potato in Idaho.* Idaho Potato Commission, Fourth Printing, December 1992.

Fritzen, Mary Jane. *Idaho Falls, City of Destiny.* Bonneville County Historical Society, 1991. (Published by No. 1 Printing, Greg Poulter, Idaho Falls, Idaho).

Jensen, Deanna Lowe. *Let the Eagle Scream, Senator Frederick T. Dubois, The Man and His Times.* Idaho Falls, ID: Wildfire Press, 1999.

Lovell, Edith Haroldsen. *Captain Bonneville's County.* Idaho Falls, ID: The Eastern Idaho Farmer, 1963.

Madsen, Brigham D. *The Northern Shoshoni.* Caldwell, ID: Caxton Printers, Ltd., 1980.

Madsen, Brigham D. *The Bannock of Idaho.* Moscow, ID: University of Idaho Press, 1996.

Madsen, Betty M., and Brigham D. Madsen. *North of Montana! Jehus, Bullwackers, and Mule Skinners on the Montana Trail.* Logan, UT: Utah State University Press, 1998.

McKeown, William. *Idaho Falls, The Untold Story of America's First Nuclear Accident.* Toronto, Ontario, Canada: ECW Press, 2003.

Peterson, F. Ross. *Idaho.* New York: W. W. Norton & Company, Inc. and Nashville, TN: American Association for State and Local History, 1976.

Plastino, Ben J. *Coming of Age: Idaho Falls and the Idaho National Engineering Laboratory 1949–1990.* Chelsea, MI: Bookcrafters, 1998. (Copyright Margaret A. Plastino, Idaho Falls, Idaho, 1998).

Penson-Ward, Betty. *Idaho Women in History, Vol. 1.* Boise, ID: Legendary Publishing Company, 1991.

Schwantes, Carlos Arnaldo. *Hard Traveling, A Portrait of Work Life in the New Northwest.* Lincoln, and London: University of Nebraska Press, 1994.

———. *So Incredibly Idaho! Seven Landscapes that Define the Gem State.* Moscow, ID: University of Idaho Press, 1996.

Stacy, Susan M. *Proving the Principle, A History of the Idaho National Engineering and Environmental Laboratory 1949–1999.* Idaho Falls, ID: Idaho Operations Office of the Department of Energy, 2000.

Young, Virgil M. *The Story of Idaho.* The University Press of Idaho, 1977.

Walker, William Holmes. *The Life Incidents and Travels of Elder William Holmes Walker and his association with Joseph Smith, the Prophet.* Bountiful, UT: Copyright Horizon Publishers. Second edition published by John Walker Family Organization, 1971.

ACROSS AMERICA, PEOPLE ARE DISCOVERING SOMETHING WONDERFUL. *THEIR HERITAGE.*

Arcadia Publishing is the leading local history publisher in the United States. With more than 3,000 titles in print and hundreds of new titles released every year, Arcadia has extensive specialized experience chronicling the history of communities and celebrating America's hidden stories, bringing to life the people, places, and events from the past. To discover the history of other communities across the nation, please visit:

www.arcadiapublishing.com

Customized search tools allow you to find regional history books about the town where you grew up, the cities where your friends and family live, the town where your parents met, or even that retirement spot you've been dreaming about.